Hajo Düchting

PABLO PICASSO

PRESTEL
Munich · London · New York

CONTENT

Context

Guillaume Apollinaire

"YOU'RE FINALLY TIRING OF THIS ANCIENT WORLD O SHEPHERD EIFFEL TOWER THE FLOCK OF BRIDGES BLEATS THIS MORNING."

SPOTS

In a turbulent time and after two unsuccessful earlier visits, Picasso finally settled in Paris in 1904. The city was flourishing as never before. It was the sophisticated heart of Europe, and people came from every corner of the world to see for themselves the miracles of new technology and the numerous art treasures—and also to enjoy the world of carefree pleasures it offered.

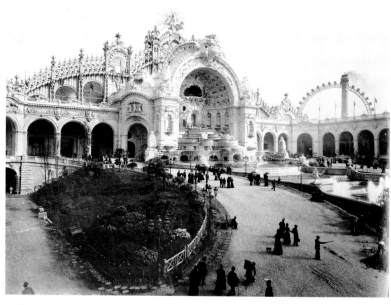

At the 1900 World Fair in Paris, the miracle of electricity was celebrated in a specially constructed Palais de l'Électricité.

Paris Lit Up

After the dull, foggy world of gas lighting, Paris was provided with electric lights around the turn of the 20th century. This new form of lighting lent Paris a touch of magic and fairytale. Not only the theaters and other public buildings were filled with light: the main streets and boulevards of Paris shone at night with the new brilliance of arc lights beneath which it was even possible to read a newspaper. Electricity became the miracle of modernity, satisfying mankind's dream of readily available power.

Montmartre, Island of Artists

no march
maw ch

The hill of Montmartre (the Butte) rose out of the hustle and bustle of the city, an island of

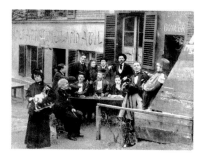

low-rent houses and cottages hidden in a riot of greenery, narrow alleys, and back streets where lovers, junk dealers, petty crooks and artists rubbed shoulders. At the time, Montmartre attracted artists from all over Europe, and often from the United States, not simply because of the low rents but also because of its idyllic

setting and the romance of its cultural life. People ate, drank and talked endlessly in the famous (or notorious) artists' bar *Au Lapin Agile* (above), which was later renamed the *Cabaret des Assassins* (Assassins' Tavern). This was where Aristide Bruant, the celebrated singer of the day, put on his best performances, and where the "Picasso gang" met to discuss art and plot new tricks to play on the artists of other schools and styles. In the *guinguettes* (cabarets) such as the *Moulin de la Galette* (above right) immortalized by Renoir and Picasso, arty types met to dance and flirt away the evenings far from the cares of

everyday life. In the middle of the steeply rising alleys was the Bateau Lavoir, a run-down building where Picasso had his first studio.

The Eiffel Tower

New structures of iron were changing the face of Paris. The most famous iron building of the 19th century was Gustave Eiffel's Eiffel Tower (1887–89), which along with the Galerie des Machines (1889) was the technical sensation of the 1889 Paris World Fair. The tower was constructed of iron girders of standard commercial sizes. Standing on four broad feet resting on blocks of concrete set deep in the ground, it reached what was then a dizzying

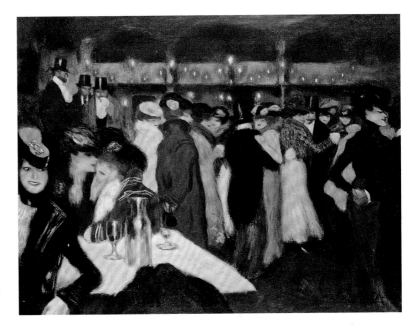

height, 312 meters (1,090 feet), making it the tallest building in the world at that time.

Impressionism

When it first appeared in the 1860s, Impressionism aroused hostility and derision. By 1900, however, it was am established, popular style that had even influenced fashion and furnishings. By then, the Impressionists themselves had already withdrawn from the Paris art scene. Monet, for example, had retired to the peace of his gardens in Giverny which provided him with endless subject matter. Cezanne was in his native Aix-en-Provence, tirelessy working on a style that,

going beyond Impressionism, would have a profound impact on modern art and on Picasso in particular.

In those days ...

... Paris was one of the richest and most alluring cities in the world. With its famous buildings and art treasures, but also its pleasure palaces, such as the *Moulin Rouge*, it became a magnet for tourists from all over the globe.

... studying at the official Académie des Beaux-Arts was strictly regulated. That's why many would-be artists sought teachers in the city's numerous art studios and other art schools.

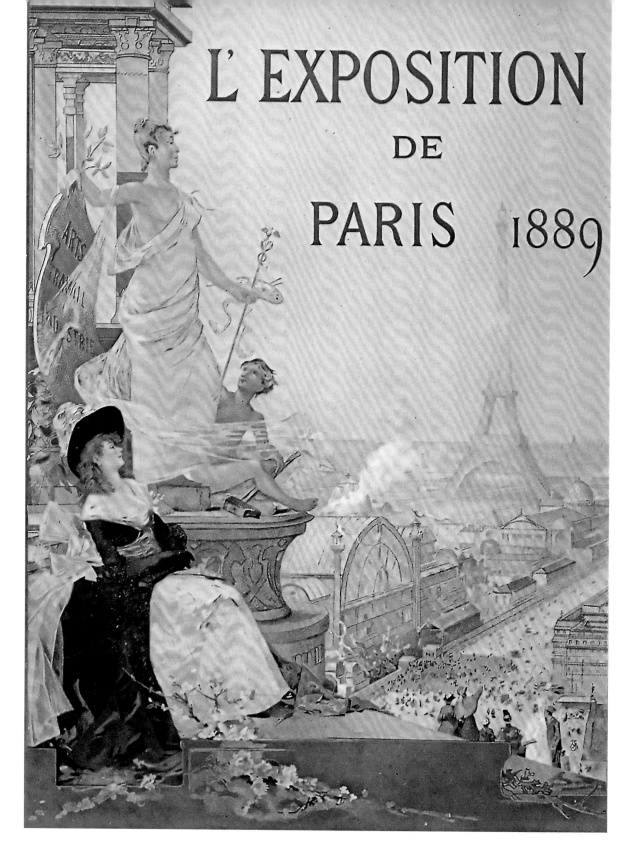

L' EXPOSITION
DE
PARIS 1889

The huge social and intellectual changes at the end of the 19th century lad to profound unease in people's view of the world and themselves. Art served as a guide. In novel forms of expression, it portrayed both the decline of established values and the emergence of a new understanding of the world.

The World Transformed

Between 1880 and 1930, the world underwent a complete transformation. Far-reaching changes affected virtually all aspects of life. And these were not only scientific and technical developments—attitudes, beliefs, expectations, and even moral attitudes all changed profoundly. Art held up a mirror to society, and Picasso was the one who held it longest.

▬ The Cradle of Modernism

It was the utilization of the steam engine in the 19th century that ushered in the modern era. Probably no single invention in the modern period brought about so many changes within such a short space of time. As a result of the construction of large factories and innovations in methods of production, new social classes arose that needed mass housing and the facilities of urban life. The growth of the main cities of Europe was so rapid and so great that new approaches to urban planning were needed. Paris had already seen major change from the 1860s, when Baron Haussmann rebuilt the city into one of the first modern metropolises, cutting broad thoroughfares through the mediaeval labyrinth of often ramshackle alleys and run-down streets. The grandiose boulevards he built were intended not only to improve the quality of life for the people of Paris, but also to provide improved security for the government—keenly aware of the violence that erupted during the Paris Commune (1870/71), the authorities saw broad, straight streets as the best means of bringing any outbreak of civil unrest under control quickly.

Another important project was the development of the rail network and the building of great stations such as the Gare de l'Est, which in turn mean the construction of broad thoroughfares connecting the stations. By 1870, France had around 16,900 kilometers (10,000 miles) of main lines radiating from the capital, linking it with all cities, large towns and important regions of the country, and of course with other European capitals. Among the urban amenities introduced during the Haussmannization of Paris were parks like the Bois de Boulogne, and also such buildings as Les Halles, the famous (now demolished) iron-built wholesale food markets designed by Victor Baltard and immortalized by the writer Zola in his novel *Le Ventre de Paris* (1873).

left
Poster for the 1889 World Fair with the Eiffel Tower.

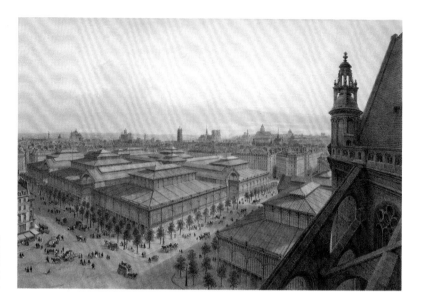

The famous (and now demolished) Les Halles food market, built to a design by Victor Baltard.

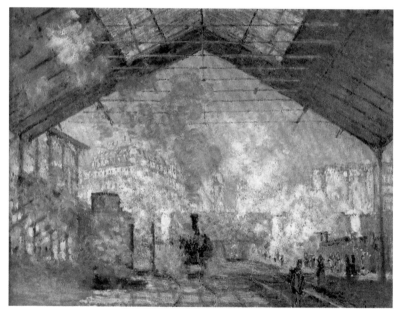

Claude Monet's *Gare Saint-Lazare* (1877) documents the artist's enthusiasm for technological progress.

The Impressionists

Today it is almost impossible to imagine the confident sense of optimism and progress that was felt for everything new and forward looking. And it was felt not only by scientists and engineers, but also by artists. Motion, speed, and transience became the new subject matter of painting. The Impressionists sought to capture the various immediate and ephemeral impressions that open-air scenes

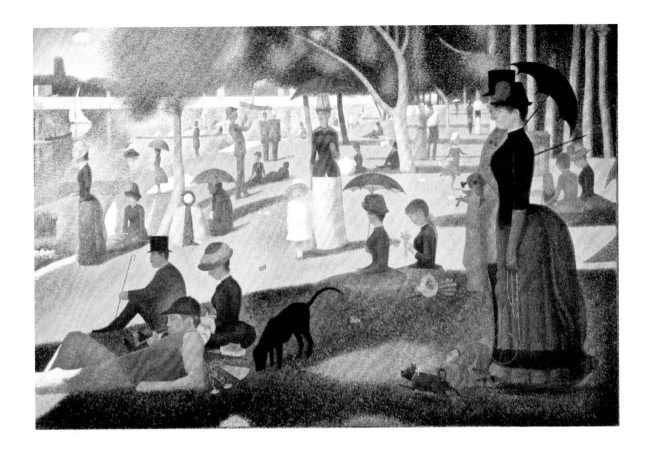

made on the eye, as in Claude Monet's *Haystack* series, for example. The Neo-Impressionists who followed broke down a painting into a patchwork of small dots of color that blend in the eye to produce an effect of great purity and tonal brilliance, an approach seen in particular in the laws of optical mixing that Georges Seurat studied.

Georges Seurat's *Sunday Afternoon on La Grande Jatte* (1884–1886) shows a Pointillist view of Paris's middle classes enjoying the outdoors.

▬ Modern Paris

It was Seurat who produced the first artistic images of the Eiffel Tower, which was then the quintessence of modernity and a symbol of cosmopolitan Paris. Constructed at the center of attractions at the 1889 Paris World Fair, the Eiffel Tower showed what the modern age could achieve. At 312 meters (1,090 feet), it was the highest building in the world at that date, and represented the victory of the industrial revolution over the past. What was novel about the building was not just its height, towering over the whole of Paris, but its structure, which required a total of 18,038 individual pre-

Camille Lefebre's *Levassor Monument* (1907) is the first-ever monument to an automobile. It celebrates the great race of 1895 from Paris to Bordeaux and back, won by engineer Émile Levassor in an automobile he built himself.

fabricated sections such as had previously been used mainly in the construction of bridges. Which is not surprising, for its designer was not an architect but an engineer and bridge-builder, Gustave Eiffel (1832–1923). He had already made a name for himself with the first department store in Paris, Bon Marché (1876), which was based on the Crystal Palace in London (1851). In its day, the latter, built entirely of glass supported by a thin iron framework, had been considered a miracle of technology and seemed to contemporary visitors a fabulous fairytale palace.

This new openness and transparency of construction was pursued to a dizzying height in the Eiffel Tower. From the second platform, a spiral flight of steps winds its way to the top, from where there is an extraordinary view over the rooftops of Paris. However, not all Parisians were enthusiastic about the Tower. Even before it was built, an article appeared in the Le *Temps* newspaper headlined "Artists Protest," signed by the artist Ernest Meissonier, the composer Charles Gounod, the architect Charles Garnier (who designed the celebrated Paris Opéra), the writer Guy de Maupassant, and others, who protested in strong terms against the new structure, prophesying that Paris would be threatened by a "gigantic black factory chimney." The Eiffel Tower did indeed dominate the view over Paris; and at the same time it could be seen from all sides as the new focal point of the city. This dual dominance and visibility in the cityscape certainly impressed other artists and writers, who celebrated the Tower as the prime symbol of the New Age. Between 1909 and 1937, Robert Delaunay painted several dozen Eiffel Towers in a wide range of styles and views. The writer Blaise Cendrars, who accompanied Delaunay on his daily walks around the Eiffel Tower, described the painter's enthusiasm for the new subject:

"So many ways of treating the Eiffel Tower. Delaunay wanted to interpret it artistically … He took the Tower apart to get it into his frame, he … tipped it up so as to comprehend its dizzying 300-meter height, he took ten viewpoints, fifteen perspectives, this part from below, that one from above, the surrounding houses shown from the right and the left, from a bird's-eye view, at ground level …"

This description captures very graphically the Cubist painter's working technique, fragmenting the subject into different views and then reconstructing it in terms of a new artistic vision.

■ Dynamism of Modernity

The prospect from the Eiffel Tower literally changed the way people saw things. Its view over Paris, the *vu d'en haut* (view from on high), seeing it like a laid-out map, was enjoyed by millions in the first 20 years of the Tower's existence. It was just as momentous in its time as the famous NASA photo of the Earth was 80 years later, seen from the Moon. Artists' ways of seeing had already begun to change. Instead of using traditional perspective and unambiguous visual spaces, Paul Gauguin and the Nabis group of artists had put together flat, colorfully patterned paintings, a foretaste of the imminent arrival of abstract painting.

This contemporary postcard records the legendary flight of a model of the Wright Brothers' plane around the Eiffel Tower in 1909, piloted by Charles count de Lambert.

The new perception also had to adjust to the new pace of life in the cities—the dense, ceaseless flow of traffic in which the first automobiles competed with countless horse-drawn cabs, the tides of humanity moving up and down the boulevards, the speed of trains, and the conquest of the air with the first flying machines. In 1909, French pilot Louis Blériot flew across the Channel from Calais to Dover. When he returned to France, his aircraft was carried through the streets of Paris in triumph and hung up in a deconsecrated church (now the Musée des Arts et Métiers) like the remains of a fallen angel. The increasing pace of scientific and technical invention transformed the Belle Époque into a crowded laboratory of ideas from which no field of human knowledge seemed excluded.

The scientific and technological foundations of the 20th century were in fact laid during the first 25 years in the life of the man who, born in 1881, would become the best known and most representative artist of the modern age, Pablo Picasso—diesel engines and the first Ford automobiles (1893), film projectors, gramophone records (1894), X-rays (1895), radium, the magnetic storage of sound, the first radio broadcasts, the first motorized flight by the Wright Brothers (1903), Einstein's theory of relativity (1905).

But it was not so much particular inventions that influenced the modern way of life between 1880 and 1914 as the increasing tempo of scientific and technological advances, which seemed to promise to make everything possible. But how was such an age to be captured in art? How could the dynamism appropriate to the machine age be expressed visually? How could one capture a world whose key features were dynamic, always changing, and fractured into pieces—indeed invisible to the naked eye—with the simple, age-old resources of painting, in other words paint and canvas?

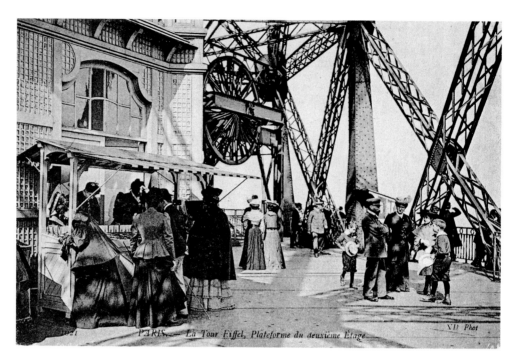

Contemporary postcard of the second-level platform on the Eiffel Tower.

PARIS. — La Tour Eiffel, Plateforme du deuxième Étage.

▬ Art's Response

It was Cubism that first offered an answer to these questions. Despite using the traditional subject matter of still-lifes, portraits, and landscapes, Cubist paintings by Picasso and Georges Braque, Fernand Léger, and Juan Gris came up with a completely new idiom—an initially incomprehensible mosaic of geometrical fragments that form a recognizable image only at the second or third glance, and that constitute something nameable only by means of inserted symbols, like puzzles combining words and images. Picasso and his fellow artists were not aiming for abstraction, a step taken by a later generation, but were trying primarily to solve basic visual problems such as how to convincingly depict three-dimensional shapes on a two-dimensional surface. A solitary painter who had withdrawn to a remote part of the south of France to work had shown them the way: Paul Cézanne. More than any other artist before him, Cézanne patiently explored the relativity of seeing, the relationships between objects and visual space. The question was how to bring these infinitely subtle and diverse relationships into a painting, and it was only as a result of a process of painstaking analysis that pictorial motifs such as grass, stone, tree, and mountain gradually emerged.

Street traffic in Paris around 1900, when horse-drawn cabs, bicycles, and early automobiles crowded the boulevards.

For the artists who came after Cézanne, this grouchy old painter, who had been ignored or completely underestimated in his lifetime, was a revelation. What they learned from him was that the relationship between art and the world is not as obvious it may seem at first glance: everything is relative, dependent not only on where the artist stands, but also on what questions he poses.

Picasso was probably the one who asked the most questions and found the most answers to them. In doing so, his eye ranged not only over European art but also over that of non-European cultures. What came of this was nothing less than a revolution in art, a "revaluation of all known values" of the kind called for in philosophy by the German thinker Friedrich Nietzsche, and now undertaken by a Spanish artist living in what was little more than a slum in run-down corner of Paris.

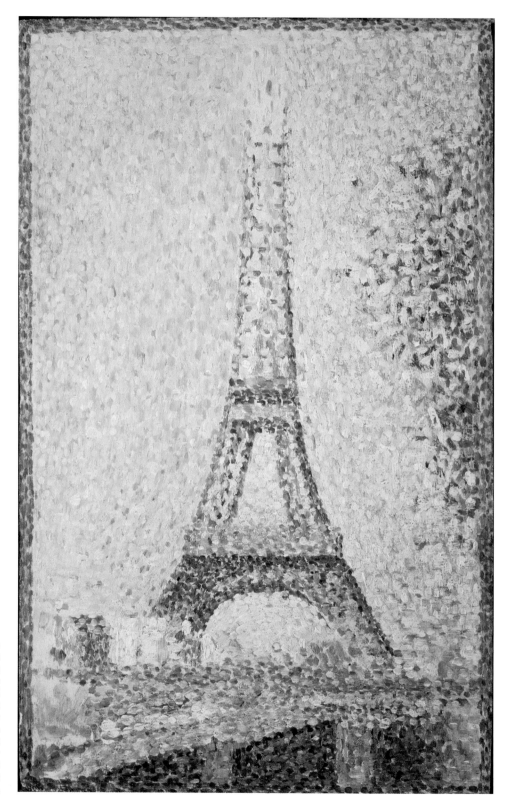

PARTS MAKING A WHOLE
The first and perhaps most telling artistic rendering of the Eiffel Tower came from the brush of Georges Seurat, who broke the tower down into a series of color dots, reflecting its serial construction technique.

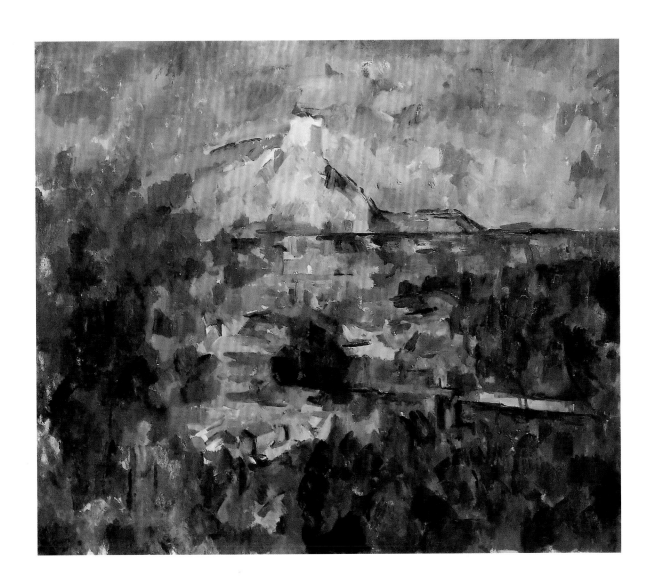

AN ARTISTIC MOUNTAIN
Paul Cézanne's late paintings of Mont Saint-Victoire manifest a high degree of abstraction. All the elements are transformed into facets of color that give the picture a solid structure and so convey a convincing impression of the inner unity and permanence of nature.

Fame

Pablo Picasso

"I WANTED TO USE DRAWING AND PAINTING—SINCE AFTER ALL THEY WERE MY WEAPONS —TO PROBE DEEPER AND DEEPER, AND TO UNDERSTAND THE WORLD AND PEOPLE SO AS TO MAKE THIS KNOWLEDGE FREELY AVAILABLE TO ALL OF US EVERY DAY ... YES, I REALIZE THAT I FOUGHT LIKE A REAL REVOLUTIONARY WITH MY PAINTING."

SPOTS

Even when young Picasso achieved remarkable artistic successes. He ran through the whole gamut of an academic career before plunging into the adventure of modernism. His curiosity drove him to search for wholly new sources of artistic inspiration, such as African tribal art. His unquenchable creativity drove him on and on, never allowing him to be satisfied with what he had achieved.

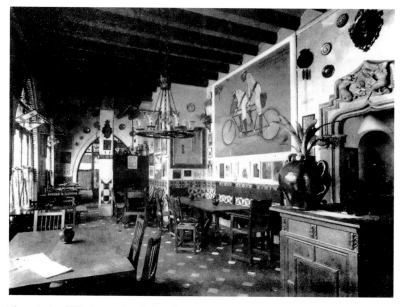

The artists' café Els Quatre Gats in Barcelona around 1899.

Between Barcelona and Paris

In the early years of his artistic career, Picasso moved back and forth between Barcelona and Paris without being able to make up his mind where to settle. Around the turn of the century, Barcelona vied with Paris as a city of art. In cafés and artist dives, the merits of the latest styles of Symbolism and Art Nouveau were hot topics of discussion. The most fashionable watering hole for artists was the *Els Quatre Gats* cabaret. Here, Picasso did caricatures of his generally older friends and colleagues that were then stuck on the walls. He designed a menu for it in the clear colors and black outlines of the Nabis artists. In early February 1900, he exhibited portraits and drawings as well, pastiches in the style of Degas and Toulouse-Lautrec.

Picasso's Dealers

Picasso had made the acquaintance of dealer Pedro Mañach at the Galerie Berthe Weill during his first trip to Paris at the end of 1900, and signed a contract with him for two years. Under it, Mañach paid Picasso 150 francs a month for all the works he created during this period. The first exhibition in Paris took place in June 1901 at the gallery of Ambroise Vollard (large image above), and for years Vollard was Picasso's principal dealer. During the Cubist period, Daniel-Henry Kahnweiler was his dealer, providing him with recommendations and helping out in a difficult time (few other were initially interested in Cubist art). After an interruption during World War I, Kahnweiler again acted as Picasso's dealer, but had to share the sale of the increasingly expensive pictures, drawings and prints with other galleries and dealers, such as Paul Rosenberg and Paul Guillaume.

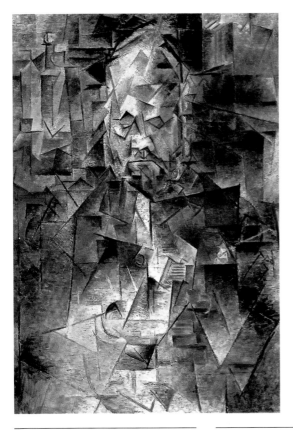

while Picasso painted, and during the day Picasso slept in the bed when Jacob went out to work. Max Jacob moved with him to the Bateau Lavoir as well, and the two men remained close. Later acquaintances were Georges Braque and Juan Gris, who were fellow artists also searching for a modern idiom.

of the huge inheritance tax imposed by the French state.

Bohemian Paris

Initially, Picasso mixed with Spanish friends in Paris, who made their studios available to him. But he soon met French painters and writers, who coalesced into a group around him, the *bande à Picasso* (the Picasso gang). One of them was poet, artists and critic Max Jacob (photo), with whom Picasso shared a tiny room in the Boulevard Voltaire. At night, Jacob slept on the narrow bed

Picasso's Legacy

After Picasso's death, his widow Jacqueline Roque donated his precious collection of paintings by Le Nain, Chardin, Corot, Courbet, Degas, Cézanne, Renoir, Rousseau, Matisse, Derain, Braque, Gris and Miró to the French state. Picasso's own works from his private collection formed the basis of the Musée Picasso, which was opened in the Hôtel Salé in 1985. This collection was made over in settlement

Picasso ...

... at 14 could already draw with the precision of an academician.

... at 20 (1901) gained fame with his Blue and Rose Period pictures.

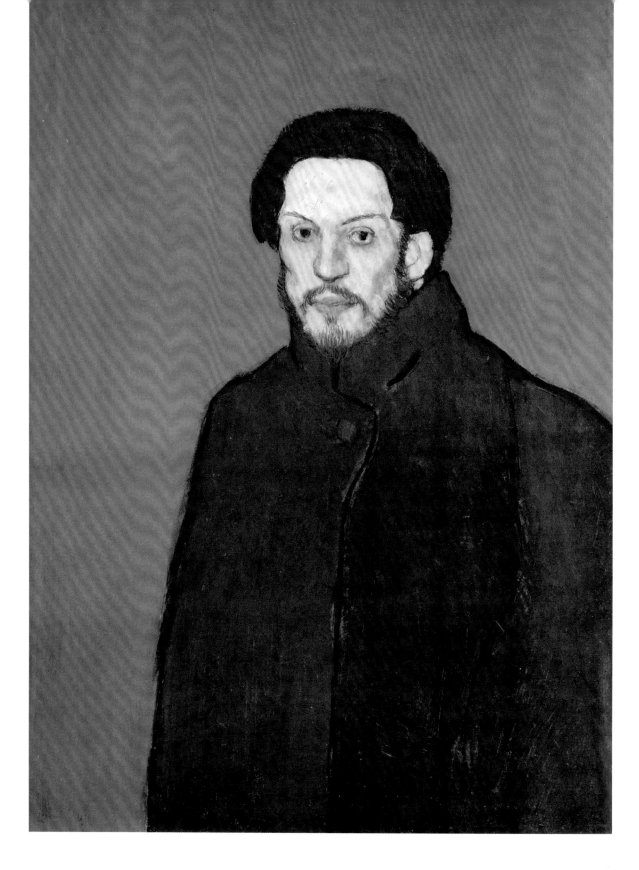

"From 28, Picasso had no money worries. From 38 he was rich. From 65 he was a millionaire." — John Berger

A 20th-Century Genius

No artist has enjoyed such wide fame in his lifetime as Picasso, nor been accorded such worldwide popular and critical acclaim at his death. Covering so many periods and styles, his works have had an extraordinary impact on the course of art history—far greater than that of Michelangelo or Peter Paul Rubens in their day.

From Child Prodigy to Immortal

Undoubtedly there has never been an artist like him in the whole history of art for attracting intense interest, whether in the media or in critical assessments and interpretations, of which there are a great many.

The art world mourned his passing as an immense loss for mankind. Having become accustomed during his lifetime to think of him as immortal, Western culture felt deserted and deceived, as if nature could produce only one such genius. His many admirers bestowed on his work an ardent worship that seemed to go far beyond any aesthetic considerations. Every painting, every drawing, every sculpture or pot, indeed any scrap of paper with a few lines or words by the master, was collected, venerated— and sold for good money.

In the 1950s, Picasso's market value attained fantastic, hitherto unknown levels that transformed the painter of modest origins into a very wealthy man.

left
Picasso's self-portrait from his Blue Period shows a somber, perhaps inwardly disturbed young artist having to cope with his first defeats and disappointments (1901).

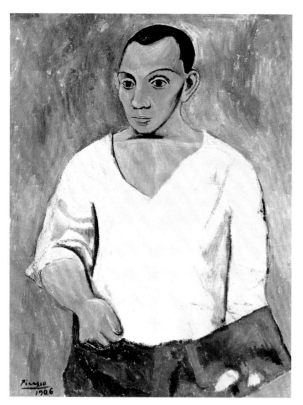

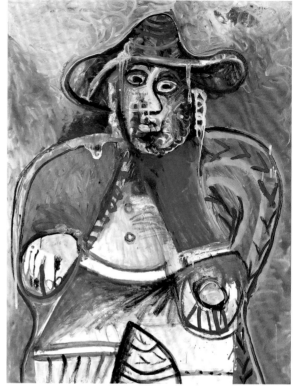

left

His *Self-Portrait with Palette* of 1906 manifests a new appetite for life, vigor, and self-assurance. Picasso was gearing up to revolutionize art.

right

At the end of his life, Picasso painted himself as a *Seated Old Man* (1970/71), with quotations from the painters he admired: the straw hat comes from Van Gogh, the crippled hand from Renoir, and the full frontal composition from Cézanne's picture *Le Jardinier Vallier*.

◼ King Midas

In fact, Picasso was well off long before the 1950s. Dealers began to buy his works in 1906. By then, the really bitter years of poverty were almost behind him. The bohemian life in the Bateau Lavoir with his lover Fernande Olivier, who shared all its hardships, was, despite all the deprivations, blessed with carefree high spirits. In the days of Impressionism, such a life-style was part of the modern image of the artist, but in Picasso's case the story tended to become myth. Picasso was later compared with King Midas, who turned everything he touched to gold. But whereas Midas almost starved in the process, Picasso could with the few rapid lines of a drawing or print relieve his financial worries at any time. Then in 1919, surprisingly, he abandoned the bohemian milieu for a comfortable middle-class life, moving with his wife Olga Khokhlova into a roomy apartment in one of the smartest districts of Paris. Along with a cook and a maid in a white apron, they had a chauffeur ready to drive them to the balls and parties of Paris's high flyers. This lasted until 1930, when Picasso bought a second home,

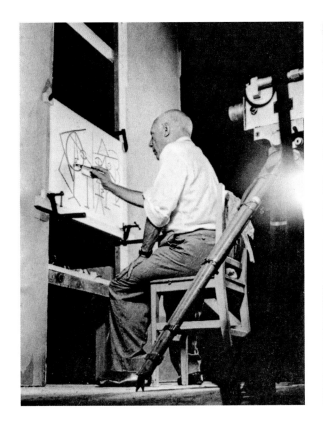

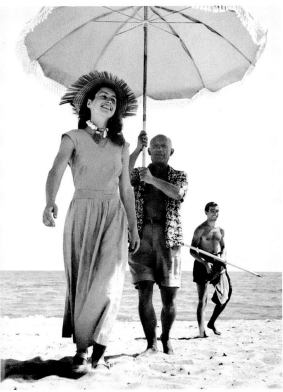

a 17th-century château at Boisgeloup, which a little later he made over to Olga after the break up of their marriage.

Other apartments, estates, villas and châteaux entered and left his life, usually marking the change from one wife or lover to the next, culminating in the purchase of Château Vauvenargues, where Picasso and the woman who was to be his second wife, Jacqueline, retired in 1958. The last scene of the Picasso drama took place there and in La Californie (a villa in Mougins in southern France), in the form of a large late oeuvre.

Myth and Creative Vitality

Why was he so blindly and often excessively admired, even if later also harshly criticised? Picasso undoubtedly made a major contribution to the image of the 20th century. His name, even if not necessarily his work, is recognized even by those who know nothing of art. The concept of Cubism is so closely linked with his name that all other painters of the time more or less vanish behind a wall

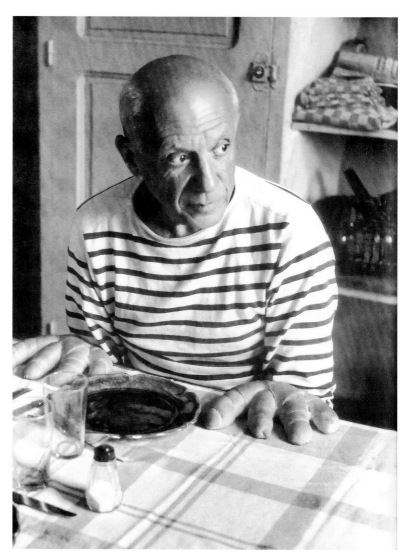

A famous photo of Picasso at breakfast with bread rolls for fingers.

with the name Picasso written on it in large letters. He pounced on virtually all genres and styles, taking them apart, destroying and smashing them so as to subsequently create a new style, the Picasso Style, out of the ruins. Once Picasso had established his own myth as a extraordinary creator of all kinds of new styles, he delighted in playing the part of a provocateur, a clown who enjoyed nothing so much as setting his admiring and amazed public a new puzzle to solve. He was just as likely to spend fifteen hours drawing a piece or nine hours standing at the easel without a break as to spend whole days on the beach or at a bullfight. He made his entire life a work of art, against a background of an apparently inexhaustible creative force, pithily expressed in the famous epigram: *Yo no busco, encuentro* ("I don't search, I find").

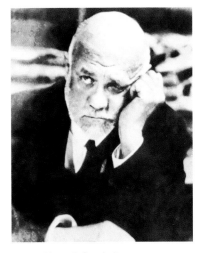

Among Picasso's first dealers was Ambroise Vollard, who had earlier represented Cézanne.

An Insatiable Appetite for Life

What certainly fascinated (and still fascinates) people about Picasso, alongside a bewildered admiration for his huge range of works—it is so vast one can scarcely take in the details, let alone understand it as a whole—was the sheer life force of this rather small, stocky but charismatic-looking Spaniard with small elegant hands and piercing eyes.

Even in the most wretched circumstances, wearing only a striped shirt and sandals, he styled himself the untameable rebel, resolved to take on every artist of his own time and even those of the past—and of course to surpass them. As his poet friend Apollinaire said of him:

German-born dealer Daniel-Henry Kahnweiler was Picasso's most loyal dealer to the end of his life.

"Picasso is one of those people Michelangelo was referring to as meriting the term 'eagle,' because they fly higher than everyone else during the day and break through the clouds until they reach the sun."

He had an insatiable appetite for life, even though in Paris, as Fernande Olivier noted, he carried a great cloud of angst around with him. In part, this shadow over his life was caused by his impatience that he couldn't live every day to the full, work without ceasing. In his later years, it was the ever-present thought of the inevitability of death that hit him particularly hard—it meant a final end to all creative work.

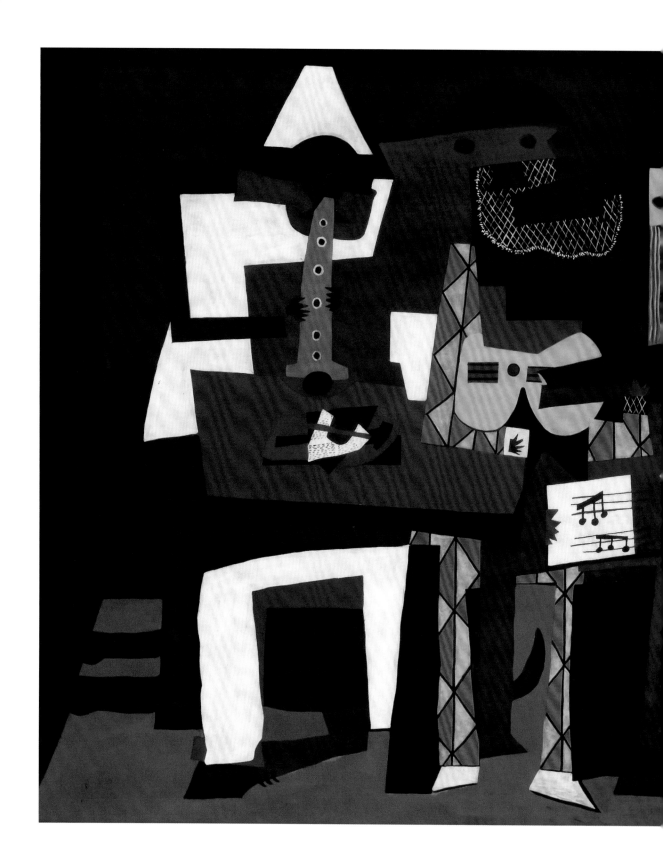

STYLISH SYNTHESIS
The picture of *The Three Musicians* (1921) is considered to be one of Picasso's most important works from the Synthetic Cubism period.

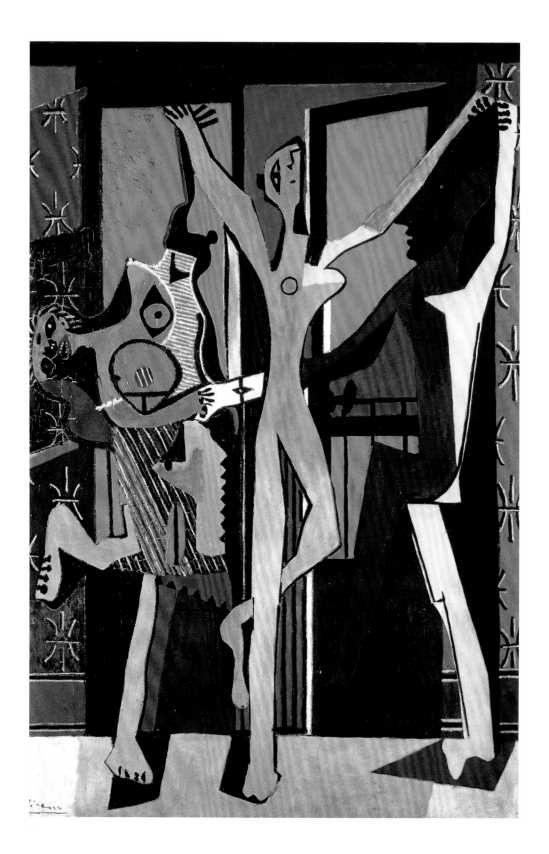

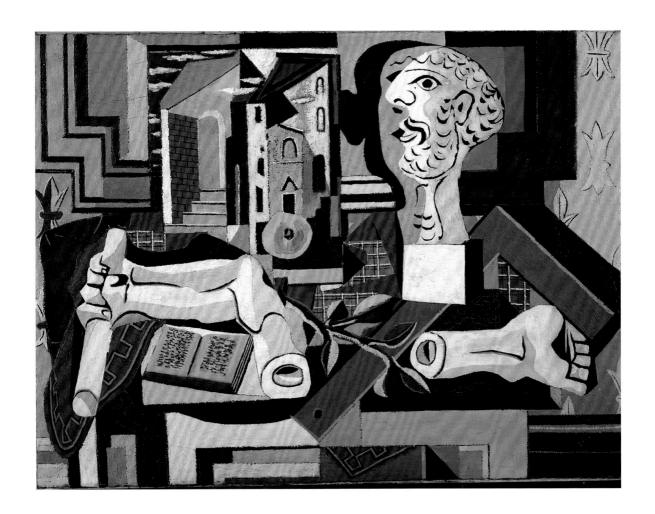

ARTISTIC IRONY
In *Studio with Plaster Head* (1925), Picasso seems to be making fun of classical models, which he drew on for his montages and reliefs. During these years, he made extensive use of classical antecedents and antique motifs.

left
CHANGE OF SUBJECT
Dance of 1925 has an eerie Dionysiac air reinforced by the shadow of Ramón Pichot, a friend of his youth who died during the genesis of the picture.

Art

Pablo Picasso

"I PAINT WHAT I SEE, SOME-
TIMES LIKE THIS, SOMETIMES
LIKE THAT. I DON'T BROOD
ABOUT IT, OR EXPERIMENT. IF
I HAVE SOMETHING TO SAY,
I SAY IT THE WAY I THINK I
NEED TO. THERE'S NO TRANSI-
TIONAL ART. THERE ARE ONLY
GOOD ARTISTS AND NOT SO
GOOD ARTISTS."

SPOTS

You can't force Picasso's work into neat stylistic pigeon-holes. Even at 19, he was so well versed in art that he could paint in any contemporary style, from Symbolism to Post-Impressionism, and even in the formal manner of the Academy. But once he had fully mastered a style, he became bored and moved on. With Cubism, he invented a new kind of painting that was a true revolution in art.

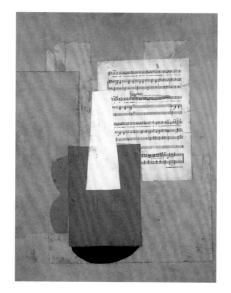

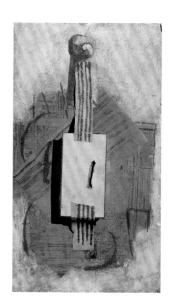

African and Oceanic Art

Walking through Paris one summer's day in July 1907, Picasso came across the ethnological collection in the Trocadéro Museum. He came away deeply impressed by the African and Oceanic sculptures and masks. They seemed the powerful expression of deep, elemental feelings such as fear, alarm, joy, and serenity. Like André Derain and Henri Matisse before him, he began to collect masks and sculptures, which at the time could be bought for very little in Paris's flea markets. Over the years, he became more and more absorbed in the formal idiom of such works, which at the time were not even recognized as art. They did not influence his work directly, but in their simple geometric shapes and coded

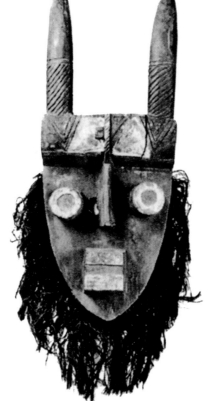

symbols they on several occasions acted as an important inspiration.

The Invention of Collage

Georges Braque was trained as a decorator and house painter, so not surprisingly the idea of sticking a piece of wallpaper on a painting so as to include its patterning in the composition came from him. Later he added other things, such as imitation wood graining and extracts from newspapers. In short, collage had been invented. Picasso tried his hand at it and turned the new technique into masterpieces. At the

A Grebo mask (Ivory Coast) from Picasso's collection.

same time, he also experimented with cardboard structures that would revolutionize sculpture. Collages and three-dimensional montages became two of the most important technical resources of modern art.

The Father of Cubism: Cézanne

Paul Cézanne (1839–1906) went through a phase of Impressionism before he withdrew to the solitude of his homeland in Provence in southern France, where he could work at peace on forging a new style. This was to be a continuation of the classic tradition, but combined with an intense study of nature. Primarily, Cézanne was inter-

ested in winning back space and depth, three-dimensionality and volume—compositional elements Impressionism seemed to have discarded. His much-quoted dictum "You have to treat nature as cones, spheres and cylinders" does not mean he anticipated Cubism. Cézanne never wanted to invented a style wholly cut off from nature. His first and only artistic objective was to intensify his perception of nature in order to consolidate his compositions.

Cubism

The term "Cubism" was taken from art critic Louis Vauxcelles's description of Braque's geometric forms as "cubes." This alluded to Braque's reduction of solid ob-

jects to strict geometrical shapes based on a study of Cézanne's late paintings. As it developed, Cubism was characterized by a very reduced palette, and by the fragmentation and faceting of objects into small, jigsaw-like components. The depicted objects were so fragmented they were initially unrecognizable, and could be understood only through small indications of a representative nature. As a result, this first phase of Cubism, from 1909 to 1912, was called Analytical Cubism. With the invention of collage, Synthetic Cubism was born, which brought back stronger colors and simpler compositions easier to interpret. The master of this phase, which lasted until the outbreak of war in 1914, was another Spanish artist working in Paris, Juan Gris.

Inspiration ...

... for the development of Picasso's works came both from Cézanne and from works of non-European art.

... for modernism as a whole— that was the significance of Cubism.

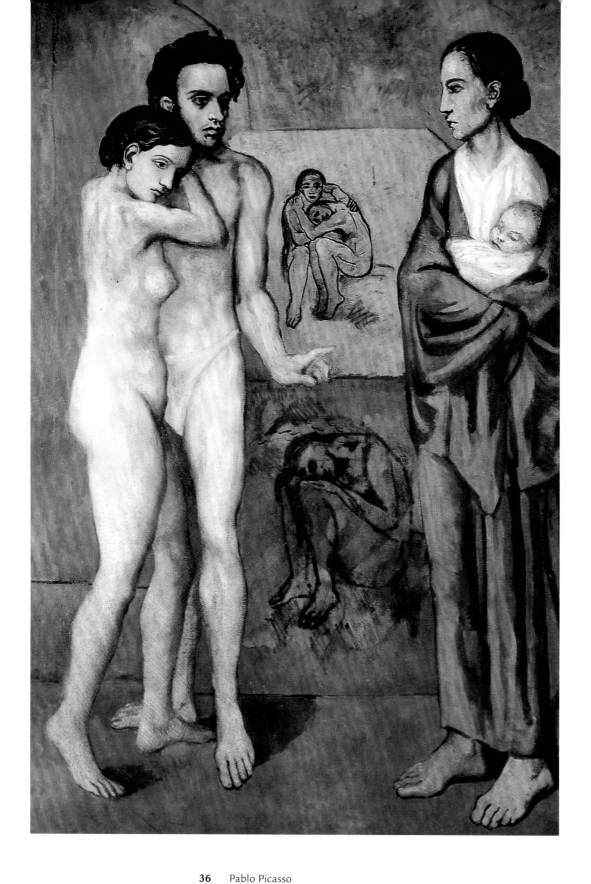

"I always endeavor not to lose sight of nature. What I want is a resemblance, a deeper resemblance that is more real than reality and so achieves the level of the surreal." — Pablo Picasso

Master of all Styles

Picasso became a symbol of untrammeled artistic freedom and the necessity of the new. Like Einstein in physics and Freud in psychoanalysis, he was seen as the representative genius of art, the Superman of painting, and not only to his friends. Even in his lifetime, he was turned into a public myth. He was always at the center of artistic controversy—and he knew how to put himself across as the winner.

▬ Early Years

Even Picasso had to go through a protracted apprenticeship. In fact, he started drawing and painting at the age of nine. His first teacher and mentor was his father, but his subsequent academic training, at the art schools of Corunna, Barcelona and Madrid, was intensive and systematic.

But academies left him frustrated. All they really had to offer was drawing from plaster casts and, later, life classes. The young Picasso searched in artistic circles in Barcelona and Paris for something better. Following a moderately successful show at the Berthe Weill gallery in Paris, in 1901 he had a very successful exhibition at the Vollard gallery, with 15 of the 65 paintings and drawings being sold even before the opening. A critic was correct in noting the influence of the many other painters that Picasso borrowed from or appropriated in this early period: "Delacroix, Manet, Monet, Van Gogh, Pissarro, Toulouse-Lautrec, Degas … But all of them just in passing, they all disappear once he has absorbed them. It is clear that his impetuousness still hinders him from creating his own special style; his personality lives precisely in this fire, in this furious youthful immediacy."

left
Life (*La Vie*) (1903) is one of the most important pictures from Picasso's Blue Period. Oriented to the popular theme of the ages of life, the picture show a fear that haunted the artist—the fetal position of the crouching figures in the drawing on the wall symbolize the artist who has not found his voice.

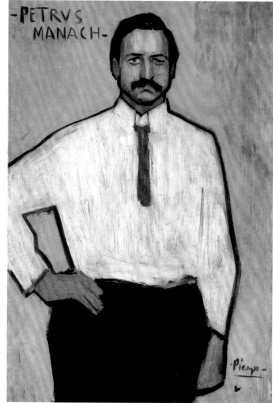

left
In his early days, Picasso cleverly played
with the styles of predecessors, in this case
Van Gogh and Toulouse-Lautrec.

right
Picasso's first dealer, Pedro Mañach,
who helped to establish the young Picasso
in Paris (1901).

This conquest and processing of other styles was to a certain extent a mark of every stylistic phase of Picasso's career. He looked at and explored anything that interested him, transforming it into something new. It could start with a classical vase, a Roman sarcophagus, an Iberian or African sculpture, old masters such as Poussin, Delacroix or Velázquez, or modern masters such as Monet and Van Gogh. To process these in his imagination, he had to take all these sources as starting material, analyze them, reshape them, and finally synthesize them using the virtuosity and inventiveness that was the essence of his creative talent.

Despite the first sales successes, his situation in Paris did not change in the long term. Exhausted by poverty and constant work, and disappointed by the public's indifference, he returned to his family in Barcelona and began to visit the artists' cafés there once again.

Blue and Rose Periods

This *Self-Portrait* of 1901 (see p. 22) marks a first turning point. The stance of the hungry figure has little in common with the later victory poses of the successful artist. In Barcelona and Paris he now threw himself into the bohemian way of life, of the kind conjured up by Toulouse-Lautrec's dancers and prostitutes of the *Moulin Rouge*. If Picasso had stuck to his late Impressionist style, the Paris of the Belle Époque would have been at his feet: but he would have remained a derivative, middle-ranking artist. With his Blue Period he entered really new territory for the first time, orienting himself to his feelings rather than artistic antecedents. The public in Paris did not take to these pictures at all, which left him worse off than ever, even though he was still the key figure on the Catalan art scene. Like the Impressionists before him, Picasso found his subject matter in the cafés and bars of the big city, the dark corners of the boulevards, the shadow side of the Belle Époque. That was where the marginalized and the rejected gathered, the beggars

1871 – 1914
Beautiful Era
belle ?

and the whores, the drunks, the aged and the sick, but also the desperate lovers, the loners, and the suicides. It was not just the suicide of his friend Casagemas in a Paris café (see p. 71) that opened Picasso's eyes to this shadowy world behind the glittering promises of the city. Living conditions in artistic bohemianism, with its ever-present poverty, anarchy, and rebellion, showed him day after day the underside of all social progress, from which only the winners could profit.

The permanent move to Paris in April 1904 brought not only a change of place but also a change of style. Stimulated by the new environment of Montmartre with its artistic life, and inspired by his love for Fernande Olivier, Picasso began to lighten his palette. Gradually, the dark figures in his pictures gave way to a host of acrobats, harlequins, and dreamy youths. Because of the light and warmer colors he now used, this era in his work, from 1904 to 1906, is known as the Rose Period. Even though a veil of melancholy still hangs over some scenes, a new affirmation of life can be discerned in them, an opening up. The delicate, finely etched outlines decoratively contour the figures, which seem caught up in a dream without any recognizable narrative. Success on the Parisian art scene returned. In early 1905, he exhibited the new pictures in the Galerie Serrurière. Two poetic articles from the pen of poet and art critic Guillaume Apollinaire lead to a new friendship and fruitful collaboration. It was as if a spell had been lifted. A period of experimentation and searching began, also stimulated by his acquaintance with Gertrude and Leo Stein, who became Picasso's first collectors.

The *Portrait of Gertrude Stein* (p. 43 left) displays Picasso's new striving for clarity and three-dimensionality of form, encouraged by his study of Cézanne's late pictures, which he saw in a major retrospective in Paris. In Picasso's new paintings we also get a first glimpse of his preoccupation with ancient Iberian sculptures— Picasso was one of the first to draw inspiration from "primitive" art. In the fall of 1906, Picasso painted his *Self-Portrait with Palette* (p. 23). In contrast to the pictures of the Rose Period, the figure looks hard and wooden, the flat, coarse outlines similar to contemporary sculptures in wood. And yet a new style was on its way in pictures of this kind, a new leap into adventure that would shake the entire art world—Cubism.

The Adventure of Painting *Les Demoiselles d'Avignon*

"I detest people who talk about 'beauty.' What is beautiful? In painting you have to talk about problems! Paintings are nothing but exploration and experiment. I never paint a picture as a work of art. They are all exploration. I am always exploring, and all this searching and searching follows a logical development."
(Pablo Picasso)

There are pictures whose style and impact make them key works in the history of art. One of these is *Les Demoiselles d'Avignon* (p. 44), with which Picasso startled his friends in July 1907. "It's like … drinking … paraffin," muttered Braque when he saw the picture, alluding to the fire-eater at the Médrano Circus, where Picasso and his friends spent so much time. The starting point of the composition was a study of seven people in a brothel in Barcelona's Carrer Avinyó district, which Picasso had often visited while a young man. After endless revisions, it finished up as a group of terrifying sharp-edged female bodies with staring eyes, some seemingly wearing African masks, and rigidly frozen into their surroundings. The room is tilted

After a summer with Fernande in Gósol, a new sense of resolve and affirmation returned to his paintings.

like in a picture puzzle: the figures are not standing on the floor but have fused with their surroundings. In this kaleidoscope of splinters and bodies there is no center point, no area of stillness, no horizon. Nor is there a fixed focal point, uniform depth of space, or source of light. Whereas the first three women on the left are reminiscent of Egyptian or Archaic Greek models, the two extraordinary women on the right surprise us with the bold expressiveness of African tribal art. This picture was Picasso's opening salvo in the struggle against the tradition of painting, which he nevertheless used again and again as an inexhaustible treasure trove of forms and colors.

■ The Formal Language of Cubism

"You have to destroy the picture, rework it several times over. Any time an artist destroys a beautiful discovery, he does not actually suppress it but transforms it and condenses it, to make it more fundamental." This was how Picasso described the restless process of creating a painting. Cubism evolved from a series of landscape studies Braque and Picasso had made in the south of France while on the trail of their great inspiration, Cézanne.

But what is a Cubist picture? Picasso and Braque did not want to overthrow the tradition of naturalism with the new style but just to bring back shape and three-dimensionality into painting. It was still real-life objects that acted as the starting point of paintings—still-lifes, landscapes, and portraits like those of art dealers Vollard and Kahnweiler (p. 21). The elementary constituents of painting were to be derived from the following: a non-illusionist approach, geometrical shapes, simple volumes, muted colors, and finally balance, which makes a composition out of all these elements. Construction and deconstruction were harnessed to the same creative urge to "paint new totalities with components borrowed not from visual reality but reality as *understood*," as Apollinaire described it.

In short, it was not about imitating objects but creating new objects to look at, independent visual objects, harmoniously balanced visual structures with formal elements that mutually responded to each other: curves to straight lines, color fields to blank areas, dark to light, optical illusions to their opposites. This delight in dismantling and reconstructing went so far that the pictures became almost unreadable, the initial motif being scarcely recognizable.

Here, Braque came to the rescue. He stuck pieces of patterned wallpaper and cuttings from newspapers on his paintings, by way of an allusion to objective reality.

In Synthetic Cubism, the pictures became more sensual, more direct and recognizable. It's not an exaggeration to say that in many of Picasso's paintings in the years before World War I, the desire to dismember gave way to a joy in the decorative.

▬ Cubist Sculpture

Contemporaneously with the collages, Picasso also produced three-dimensional designs of cardboard and wire that he then painted. It took several stages for the shapes to develop from the flat surfaces and the fragmenting of the structures until an entirely free-standing design of painted wooden parts, nails and string emerged in 1915/16. This invention of Picasso was the beginning of revolutionary innovations in the field of sculpture that were soon adopted over by other sculptors and taken a stage further. Before, sculpture had meant either modeling (building up a figure from clay), or carving it out of wood or stone; the sculptures that now took form resulted from a process of assembling pre-existing found parts.

▬ Picasso and Neo-Classicism

Between 1916 and 1925, Picasso revisited his academic roots, perhaps as a result of his experience of the theater. He often called on composer Eric Satie and writer Jean Cocteau, who put him in touch with Diaghilev, head of the Ballets Russes. Cocteau persuaded Picasso to do the stage sets and costumes for Diaghilev's *Parade*, which was premiered in Paris in May 1917. After his Cubist designs, the theater gave Picasso an opportunity and excuse to return to the human figure in an academic, classical way. The harlequins and classical masks of the Commedia dell'Arte he had already toyed with in the Rose Period now came back. During a stay in Rome, where he first met his future wife Olga Khokhlova, Picasso was inspired by Michelangelo's Sibyls in the Sistine Chapel to produce bulky female figures that run across the canvas as if in an Olympic competition, or, dressed in ancient Greek costume, disport themselves on a beach. Along with these, there were Mediterranean still-lifes with musical instruments, clearly drawn with geometrical outlines and in bright colors, which appear to be a reflection of Picasso's private happiness with Olga and his son Paulo (Paul). Picasso no longer played the role of "smasher of forms" but of a "juggler of forms," who played with shapes and colors as if with a box of bricks.

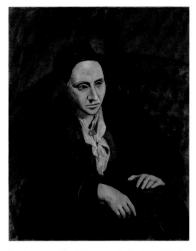

In the portrait of Gertrude Stein (1905/06), the American writer acquires a look of monumentality.

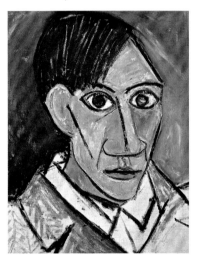

Despite the emaciated features, this self-portrait by Picasso manifests determination and energy (1907).

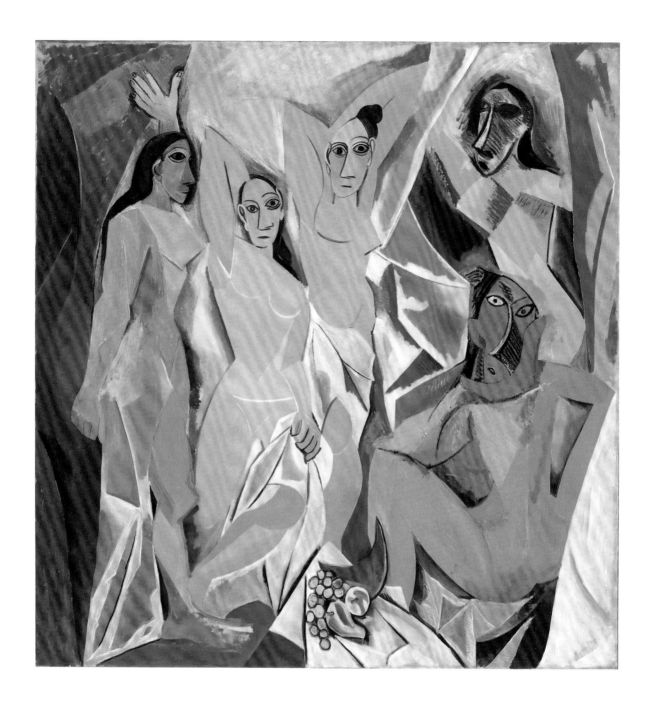

A KEY WORK OF MODERNISM

Les Demoiselles d'Avignon (1906/07) was the outcome of an unprecedented number of studies and sketches. It bears witness to Picasso's delight in experimentation and his sense of adventure on the threshold of Cubism. The strongly stylized nudes are seemingly locked into their surroundings, as if set in amber. This new hardness is a riposte to the "transitoriness" of Impressionism.

PHYSIOLOGICAL OPTICS

In the early years of Cubism, Picasso was entirely preoccupied with the formal aspects of painting. The ambivalent shapes he came up with are often like picture puzzles. Gertrude Stein is said to have introduced him to the studies of vision by the psychologists Hermann Helmholtz and Wilhelm Wundt, which were available in French editions.

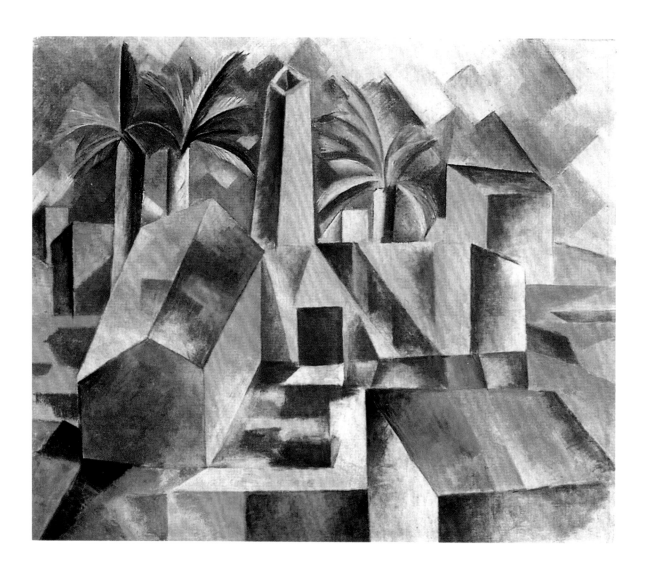

RELIEF PERSPECTIVE
The first Cubist pictures are notable for three-dimensional forms and
perspectives that tilt the subject out of the picture (1909).

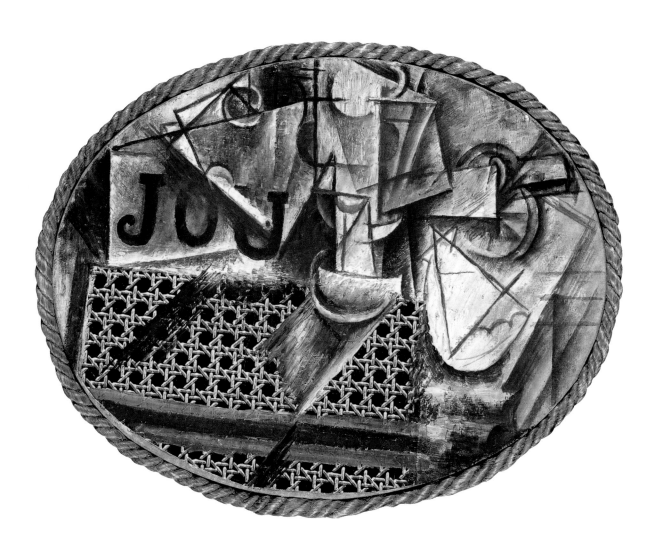

COLLAGE
Collages were Braque's invention, but Picasso soon took over the
technique and created a series of masterpieces with it (1912).

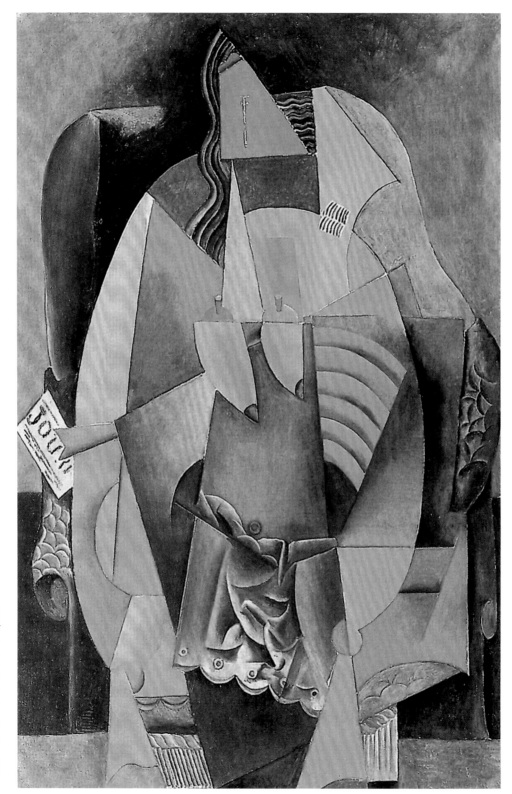

WOMAN IN A
CHAIR
After a period of
experimenting with
collages, Picasso
became so adept
that he could create
them with purely
painterly means.
Several brutal de-
tails like the "nailed
on" breasts enhance
the "defamiliariza-
tion effect" that
Picasso achieved
with this technique.

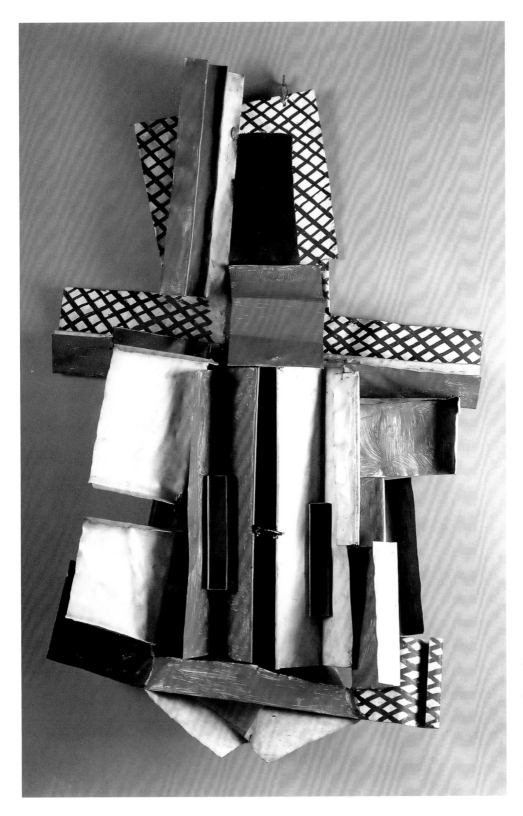

RELIEF
STRUCTURE
Picasso created his first three-dimensional structures from simple materials such as cardboard, paper, string, sheet metal and wire. The technique would revolutionize sculpture.

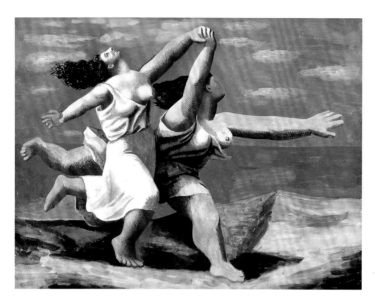

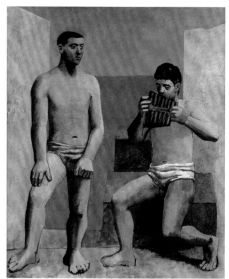

Picasso and Surrealism

In 1924, the theater called again, and Picasso agreed to do the sets and costumes for Massine's ballet *Mercure*, set to music by Satie. But this time the premiere was not a success. The only person to champion it was André Breton, who published his Surrealist Manifesto in October of the same year, where he defined Surrealism: "Surrealism is based on a belief in the higher reality of certain kinds of association still neglected even today, in the omnipotence of dreams, and the undirected play of thought." A reproduction of *Demoiselles d'Avignon* (p. 44) was first published in the fourth issue of the Surrealist periodical *La Révolution Surréaliste* of July 1925, along with the *La Danse* (1925, p. 30), dating from shortly before. The cruel deformation of the dancing figures in the latter is altogether of the same kind as the *Demoiselles* of 1907. The *Embrace* (*The Kiss*) produced not much later shows an orgiastic tangle of colors and shapes with a palpably sexual theme. Pictures like this brought Picasso close to the iconoclastic Surrealists, even though he always denied they had any influence on him. Nonetheless, he took a close look at Surrealist works, notably those of fellow Spaniard Joan Miró, whose abstract visual code may have prompted him to try out various materials and associations, as can be seen in his montages and iron structures of these years, such as *Guitar* of 1926 (p.52).

Even if he was undoubtedly fascinated by the Surrealists, no direct influence can be identified. Picasso did not have to wait

for the Surrealists to produce Surrealist works. As a "juggler of forms," he had attained a degree of artistic freedom that permitted him all conceivable technically possible combinations of forms and colors.

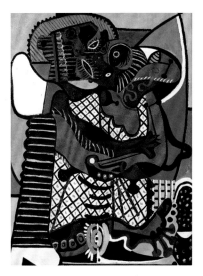

Picasso even took a tip or two from Surrealism, as this monstrous *Embrace* (1925) shows.

▄ *Guernica*: The Supreme Anti-War Image

News of the outbreak of the Spanish Civil War reached Picasso during the summer of 1936 while he was on vacation at his home in Mougins, a village near Cannes on the Riviera. Though he was basically apolitical, Picasso sided with the Republican cause. The Republicans were duly grateful, and appointed him the director of the Prado Museum, though this was only a nominal post that Picasso was never able to take up once Franco emerged victorious.

In January 1937, the Spanish Popular Front commissioned a mural from Picasso for the Spanish pavilion at the World Fair due to open in July that year in Paris. To prepare the large picture, he rented a spacious studio in the Rue des Grands-Augustins, obtained through Dora Maar. In April, the small Basque town of Gernika (Guernica) was bombed by Nazi planes, the victims being mainly women and children. Picasso took this terrible event as an opportunity to update his painting. He prepared the huge picture with numerous studies, taking over many elements from previous etchings such as *Franco's Dream and Lies*. The picture shows a massacre involving both people and animals. Helplessness is conveyed by the confined pictorial space in which man and beast are trapped and scream with fear and panic (pp. 56–57). The lamp with the rays like bolts of lightning may be taken as a symbol for the bombardment, although Picasso avoided anything clearly unambiguously. After the opening of the exhibition, the painting became first and foremost an anti-war picture, and the name *Guernica* still represents total war and all its horrors.

▄ The Triumph of the Imagination

The experiences he gained while working on Guernica enabled Picasso to elaborate a new repertoire of styles to apply in subsequent paintings, combining elements of Cubism (fragmentation) with classical graphic outlining. Double portraits combining frontal and profile views, and showing both eyes, ears and nostrils, became a trademark that occurs in almost all the female portraits of the 1940s and 1950s. The large oil painting *Weeping Woman* (p. 53

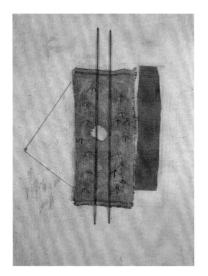

Picasso conjured up a "still-life with guitar" (1926) with the simplest of materials, an inspiration for the Arte Povera movement later.

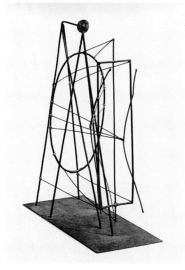

This sophisticated iron structure is a model for a memorial to Picasso's friend Guillaume Apollinaire (1928).

left) sums up the new experiments and at the same time constitutes a moving statement about human pain (as he had seen at first hand in his lover Dora Maar). The starting point of the composition was this combination of views; additionally, the figure is splintered into angular fields framed by thick lines, whose distinctive hard colors intensify the element of inner turmoil and pain.

However, Picasso's palette did gradually lighten. Long spells on the Côte d'Azur with his new lover Françoise Gilot awoke in him a renewed delight in life and in painting. Classical myths were revived, as fauns and fauna romp with dancing humans beneath a star-spangled sky. Picasso was given an opportunity to work in the old Grimaldi Château in Antibes, which was later turned into a Picasso museum with the help of a generous donation of exhibits from the artist. Perhaps the term "Picasso Style," which Picasso had sought to avoid for so long with his constant mutations, applies really only to the work of these years.

Vallauris and Pottery

Picasso's creative vitality also found expression in his fascination with old craft techniques, which, typically, he transformed for his own ends. From 1948 Picasso began to make ceramics in Vallauris, a town in the hinterland of the Côte d'Azur with an established pottery tradition. To the alarm of the master potters, Picasso broke all the rules of art even here, and tried his hand at technically impossible combinations of vases and figures. In Vallauris, Picasso found a new métier. In rapid succession, there followed vases with owl faces and handles, plates with fauns and satyrs or bull-fighting scenes, flagons in the shape of standing or kneeling female figures, tiles with women's heads, owls and doves in various positions, all of them painted in bright colors. His ten-year presence in the town brought it worldwide fame, and the Picasso legend still nourishes it, with the sale of replicas and an annual festival rounded off with a bullfight.

Picasso's Last Years

It is often said that Picasso changed his style with his women. And the last phase did indeed begin when Françoise Gilot had left him and he met the young, lively Jacqueline Roque. He found them a new home not far from Cannes, the Villa La Californie, a large and grand 19th-century summer residence with an extensive view

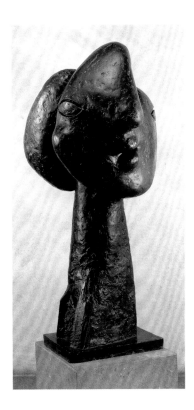

towards Golfe Juan and Antibes. By this time, Picasso had become a cult figure the world over, which increasingly drove him back behind the walls of his estate and behind his canvases. His subject matter now became more and more artificial and mannered: they were pictures within in pictures in which Picasso combined the studio situation with already existing pictures and portraits of his new wife. And, once again, he drew heavily on art history.

above
The sculptures that Picasso produced in Boisgeloup were a testimony to a revived creative urge stimulated by his relationship with Marie-Thérèse Walther (1931).

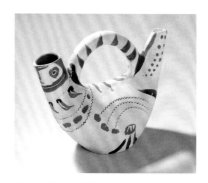

Picasso also tried his hand at ceramics, and here too produced a host of highly original pieces.

The great masters of the past offered him material he could develop: Courbet, Manet, Delacroix, Velázquez and even Rembrandt, a reproduction of whose *Night Watch* hung on the wall in his studio and which he mused on for hours. A subject that interested him, for example Manet's *Déjeuner sur l'Herbe* or Velázquez's *Las Meninas*, he would elaborate in free paraphrases time and again. It was in La Californie that Henri-Georges Clouzot shot his famous film about Picasso in 1955. It shows the old maestro painting and drawing with incredible, effortless skill, even using a flashlight to draw images in the air.

At the end of his life, the obsession that drove him on became generalized into the theme of "the painter and his model." In the last decade, the subject filled countless pictures, prints, and drawings like an obsession. In these pictures, the painter sits at the easel with his brush and palette, sometimes apparently sleep-walking or even just hungrily looking, his eyes fixed on his wife seated on the right, always completely nude, and countering his staring, analytical gaze with her large almond-shaped eyes.

When a huge exhibition of Picasso's late works opened at the Papal Palace in Avignon on 1 May 1970, with 167 paintings and 45 drawings on display, the art world hurried along, only to be shocked and bewildered. What had happened to the maestro's once so assured brushstroke, the firm shapes and subtle coloration? The pictures were a jumble of musketeers with long pipes and feathers, hurriedly daubed on the canvas and looking like playing cards in their flatness and colorfulness. Often the facial features were reduced to just a few tokens, eyes were doubled or simplified into bullet shapes. The hands resembled croissants, while the bodies were ungainly shapes broadly decorated with stripes and dots.

The musketeer was a new figure in Picasso's iconography. The Pierrots, Harlequins, acrobats, and itinerant entertainers—homeless outsiders, like the artist—were now succeeded by dashing adventurers taken from the page of Dumas's *Three Musketeers* to continue the battle for art, a role the veteran artist was still unwilling to relinquish to younger artists.

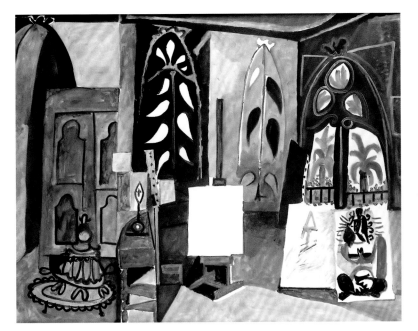

This grandiose late oeuvre was Picasso's farewell to the art world. For over 70 years he had played a leading role in it, invented, rejected, and adapting styles in order to create a colorful stylistic hodge-podge that seems to make fun of the linear development of art's various movements and -isms.

But it was this very childlike curiosity, this untamable addiction to what was new, this incessant delight in experimentation that made him the extraordinary phenomenon he is still justly regarded as even today.

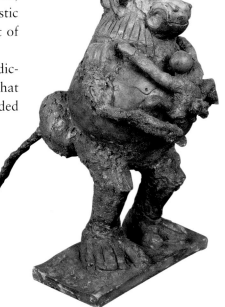

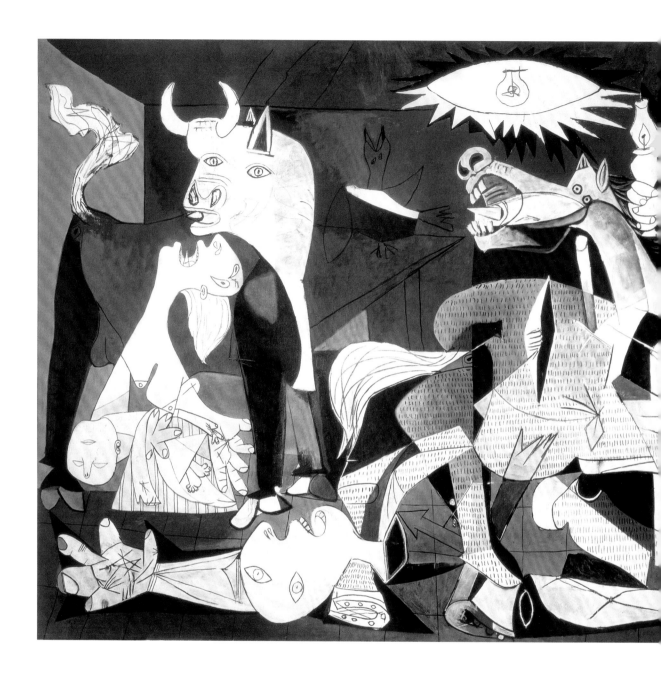

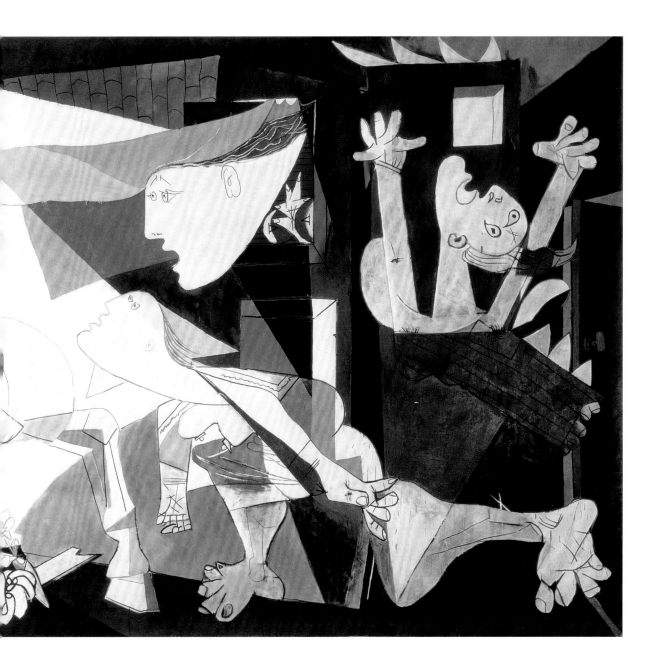

TERROR AND ANNIHILATION

The vivid depiction of fear and terror in the face of imminent annihilation made *Guernica* (1937) an eloquent anti-war picture. Although painted in response to the Nazi bombing of the Basque village of Guernica, it is not clear where and who the threat comes from. But the very anonymity of the menace makes the picture a telling protest against all violence.

THE IDYLLIC LIFE
The years with Jacqueline Roque were among the most peaceful and creative in the aging artist's life. At the villa La Californie, he painted numerous charming scenes depicted in bright colors.

right
PAINTER AND MODEL
The late works include a large number of scenes of the painter and his model, one of the oldest subjects in art. Sitting in front of his naked model, Picasso sought to reassure himself of his artistic—and masculine—powers.

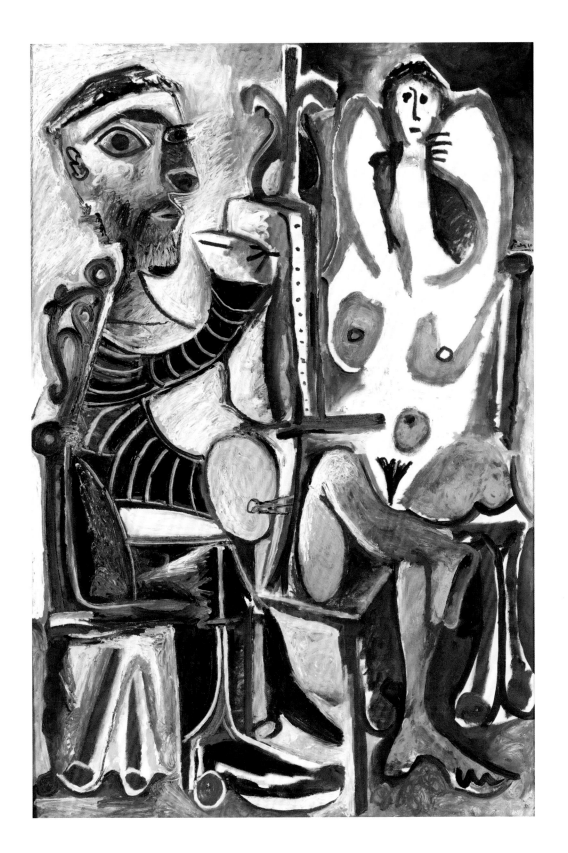

JOIE DE VIVRE

Among the pieces of good luck in Picasso's life was the opportunity to use the studio at the Château Grimaldi in Antibes, offered to him by the curator of the time, Romuald Dor de la Souchère. From August to December 1946 he "worked like mad" in the museum, using marine paints and hardboard.

The deliberate fresco effect tied in with the mythological inspiration that Picasso drew from the location. They are bucolic scenes with panpiping satyrs, centaurs and fauns surrounding a woman and joining in the dance—an expression of a new *joie de vivre* after all the deprivations and restrictions of wartime.

Life

"I'M INTERESTED IN ACHIEVING A GOAL, NOTHING ELSE— PRODUCING A RESULT, SOLV- ING A PUZZLE, PENETRATING A SECRET."

SPOTS

An eventful life doesn't always guarantee the kind of success and fulfillment that came Picasso's way, despite all the blows of fate. Born and raised in Spain, he spent most of his life in Paris, one of the largest cities in Europe, and moreover one with many of the most important art treasures. His career took off in an unprecedented manner, and made him the best-known— and richest—artist in the world.

Friends and Acquaintances

Despite his great talent, Picasso would probably never have made it on the Paris art scene single-handed. Even in the early days of poverty and hardships in the Bateau Lavoir, Picasso was at the center of a circle of painter, writer, and art-critic friends who admired him and supported him. During this period he was particularly valved and encouraged by Gertrude Stein. The strong-willed American writer invited Picasso and his first partner Fernande Olivier to her salons, where the most interesting artists and writers met and exchanged ideas. Once he had made his name and set up house with Olga, Picasso lived the life of a *grand bourgeois*. Every Sunday, he and his wife invited Paris's celebrities to

Picasso photographed by Brassaï.

Gertrude Stein in her Paris apartment.

their drawing room. Along with now forgotten aristocrats, they included artists of all kinds, musicians such as Artur Rubinstein,

composers Manuel de Falla and Eric Satie, writer Jean Cocteau, photographer Brassaï ... and of course a crowd of art critics and dealers who paid court to him every day. It was only contemporary painters he kept at arm's length, perhaps concerned about imitators ...

Picasso's Poems

Influenced by the Surrealists, Picasso also tried his hand at literature. From 1935, he produced poems that were published in the *Cahiers de l'Art*. They were composed in the semi-automatic, "subconscious" meandering style written by Surrealist poets (*écriture automatique*) and so are difficult to understand.
Here is a sample:
"Hack tear out dislocate and strike dead I stab scorch and burn caress and lap up kisses and look I ring and ring the bells until they bleed I shoo the doves from their dovecot now they have to swarm till they fall exhausted to the ground ..."

Picasso's Confession

During his life, Picasso published numerous statements about painting and art. With its intellectual clarity, his *Confession* from

Just as other people write diaries, Picasso filled notebooks with drawings. They served as studies for later paintings, but also as notes, observations, and sketched ideas. Particularly interesting volumes are the *Carnet Paris* and the *Carnet Dinard* from 1928. In them, Picasso invented and modified an inexhaustible wealth of figurative themes that later found their way into his paintings, sculptures, and prints.

An impressive ...

... career—from penniless art student to the best-known artist of the 20th century.

... oeuvre—the paintings alone number around 16,000.

... personality—he proved capable of starting afresh again and again.

1926 is one of the best things he wrote about his work:
"The 'Cubist' painters were astonished at what they'd done and looked for theories to justify themselves. Cubism was never based on a program. My aesthetic thinking as a whole was only one form of my artistic activity; it always accorded with my purely practical work."
"You want me to say, to define what art is? If I knew, I'd keep it to myself. I don't look, I find."

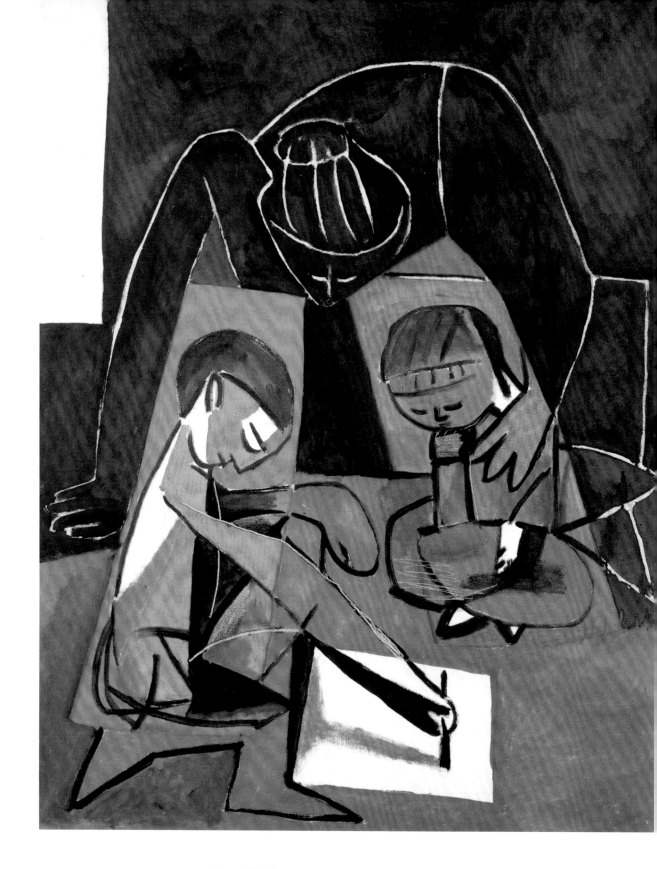

"Basically I'm a very curious person. I'm curious about every aspect, every moment and every phenomenon of life. My curiosity surpasses all bounds of curiosity." — Pablo Picasso

The Hourglass in His Head

Picasso displayed a formidable talent for drawing and painting early on, a talent lovingly encouraged by his father. But having completed an academic training, Picasso turned to the emerging artists of the avant-garde. With insatiable curiosity, but also a delight in tearing apart and re-inventing, he set about reforming the whole of Western art.

▬ A Spanish Childhood

The Picasso story began on 25 October 1881 in Malaga in the house at no. 36 (now 15) Plaza de la Merced. It was said he was born *a las cincos de la tarda*, the traditional hour when bullfighters go into the arena, i.e. five in the afternoon. According to Picasso himself, the hour of his birth was midnight—as befits those destined for greatness. He was born under the sign of Scorpio, which also, with its extraordinary influences and stellar conjunctions, promised an unusual destiny.

The small boy was christened Pablo Ruiz Picasso: in line with Spanish tradition, he was given the name of his father (Ruiz) and his mother (Picasso). Both parents were from old Spanish families, but despite his aristocratic background his father had opted for the unsettled life of a painter, providing for his family after a fashion as a drawing teacher and as the curator of the local museum. Picasso's mother is described as "small and lively, with black eyes and dark hair," while the light skin and red hair of his father earned him the nickname "the Englishman." Pablo grew up in the care of his mother and of his aunts, who also lived in the parental home.

left
Few works by Picasso show his family relationships so beautifully and lovingly as this 1954 painting of his children Paloma and Claude drawing.

Even before he could speak properly, he is supposed to have kept saying "Piz, piz!" short for "lapiz" (pencil), i.e. "give me a pencil!" Picasso's father later noticed his son's precocious talent and taught him the rudiments of drawing and painting.

With the birth of two daughters (Lola in 1884, and Concepción, known as Conchita, in 1887), Picasso's father was obliged to seek better-paid employment as an art teacher in Corunna. There, the young Picasso entered the class for drawing and ornamentation at the local art school, while his father continued to encourage and teach him. However, the latter soon had to recognize his own limitations: he specialized in meticulous pictures of doves. The story goes that one day he handed his son his palette and brush, saying he wouldn't paint any more because his son had already surpassed him. But young Pablo's academic studies left a lot to be desired, so he was transferred to a small private school run by a friend of his father's. He managed to get his school certificate only through cheating and his teacher's leniency.

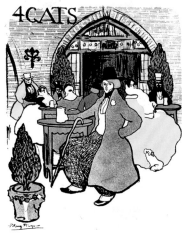

Bohemian Life in Barcelona

Picasso easily passed the entrance exam to the art academy in Barcelona, where his family had moved, while still only 14. His father now taught at the academy, and continued to keep an eye on him, getting one of his son's pictures (*Science and Charity*, 1897) into an important art exhibition in Malaga, where it won the gold medal. Picasso also applied to the academy in Madrid, did all the prescribed exams in a single day, and was immediately accepted. At this point the early independence of the young painter surfaced: instead of attending classes, which bored him more by the day, he roved about the city or went to museums in order to study Spanish painting at first hand.

Then a bout of scarlet fever forced him to return home. With Manuel Pallarés, a fellow painter from the art academy in Barcelona, he roamed up and down Las Ramblas, the main thoroughfare in Barcelona, and spent a lot of time in the city's Barrio Chino, a disreputable district where the gaunt young painter lived out his puberty.

To avoid conscription, his friend Pallarés moved back to his home village of Horta de Ebro in the inaccessible uplands between Aragon and Catalonia. Picasso soon followed him there. Later he said about these months in the seclusion of the wilderness: "Everything I know I learnt from Pallerés in the village." Apart from drawing every day, Picasso perhaps meant craft skills that he later used in making his sculptures.

left
Picasso displayed an interest in bullfights very early on. This drawing dates from 1894.

middle
The dove motif was something the young Picasso got from his father, who had established a reputation as a dove specialist. This Picasso drawing dates back to 1892.

right
The menu Picasso designed for *Els Quatre Gats* (1899/1900) displays the influence of Catalan Art Nouveau.

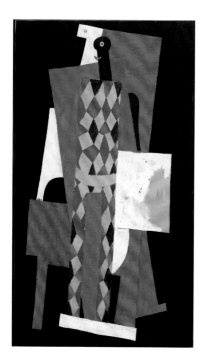

A masterpiece of Synthetic Cubism: *Harlequin* (1915).

Once back in Barcelona, Picasso (as he proudly called himself from 1901, dropping the paternal Ruiz) plunged back into the bohemian life, which meant first and foremost the café *Els Quatre Gats*.

Thanks to his talent, he was accepted among the crowd of artists and intellectuals, although the deficiencies of his education meant he was unable contribute to the debate about modern art. However, he more than compensated for that with his artistic output. On 1 February 1900, he had his first exhibition: 150 drawings were pinned to the smoke-stained walls of the room; they were mostly sketched portraits of artist, writer and musician friends.

▬ Turbulent Years in Montmartre

In October 1900, Picasso and his friend Carlos Casamegas decided to travel to Paris to see Picasso's painting *Last Moments* (later overpainted), which he had sent to be exhibited at the World Fair there. The 19-year-old Picasso was much taken with the metropolitan glamour of Paris. Day after day, he visited museums and galleries, seeing works that stimulated him: Impressionists in the Musée du Luxembourg, Degas, Toulouse-Lautrec, Van Gogh and Gauguin in the galleries on Rue Lafitte, above all those of Durand-Ruel, Bernheim-Jeune, and Ambroise Vollard. He was also fascinated by Etruscan and Egyptian art, by the Gothic sculptures in Notre Dame, and the Japanese woodblock prints on sale at the outdoor bookstalls along the Seine.

But the new century also brought tragedy. That winter, his friend Casamegas shot himself in a Parisian café over a love affair. In spring 1901, Picasso moved into a small room on the Boulevard de Clichy. His paintings were now largely painted in blue, the color of melancholy and sorrow, but also of spirituality and wisdom, particularly as used by the Romantics. Even so, he made his mark on the Paris art scene sooner than expected, especially with the assistance of the dealer Pedro Mañach, who opened all the doors of the Parisian gallery scene to him. His first exhibition at Vollard's gallery was spoken of positively, and also brought some financial success, but still not enough to pay for a decent room with a studio. At Vollard's, Picasso made the acquaintance of a remarkable young man in a threadbare suit, shabby shoes, and an immaculate top hat worn at a jaunty angle. This was Max Jacob, writer and art critic, but above all a clown and practical joker who remain one of Picasso's most loyal friends.

Due to want of money, the two of them soon found themselves sharing a small room on Boulevard Voltaire. At night, Jacob

slept in the sole narrow bed in the large room while Picasso painted, and during the day Picasso slept as Jacob worked. However, by April 1904 Picasso was able to find himself a studio of his own in Montmartre, at no. 13 Rue Ravignan (now Place Émile-Goudeau). Max Jacob called the rickety structure the "Bateau Lavoir," alluding to the laundry boats on the Seine. This was because on his first visit he had been welcomed through a dense line of washing. Picasso's furnishing was Spartan, as his lover Fernande Olivier wrote in her memoirs: "Large unfinished pictures stood in the studio, where everything spoke of work. But what untidiness to work in ... my God! A mattress on four legs in one corner. A small cast-iron stove with a yellow earthenware basin on it that served as a wash bowl; a towel and piece of soap lay beside it on a pine table. In another corner, a trunk painted black provided rather uncomfortable seating. A wicker chair, an easel, pictures of all sizes, tubes of paint scattered all over the floor, brushes, turps containers, a bowl for aqua fortis [etching acid], no curtains. In the table drawer there was a tame white mouse that Picasso looked after tenderly and showed to everyone."

Picasso began to draw and paint in a neo-classical style even during World War I. This portrait of Olga was completed in 1917.

The lovely Fernande, an artist's model, lived with Picasso for five years (1905 to 1910), during the early years of Cubism. In the fall of 1905, in a bar near the Gare Saint-Lazare, Picasso also made the acquaintance of an impetuous, impassioned poet called Guillaume Apollinaire. Eloquent and genial, Apollinaire was as interested in painting as in literature, and was to be one of the first to publish a study of Cubism. He soon became a close friend of Picasso's.

In September 1909, Picasso and Fernande left the Bateau Lavoir and moved into a large, light studio apartment in no. 11, Boulevard de Clichy. The middle-class way of life they adopted there, with meals served regularly by a maid in white apron, mahogany furniture and large grand piano, was initially much to Picasso's taste. But he could not tolerate the deceptive tranquility for long and threw himself back into the adventure of painting, sticking scraps of paper, bits of cord and imitation fabrics on his increasingly abstract pictures. With the invention of collage, Braque and he took further huge steps towards modernism.

Together with his new lover, Marcelle Humbert, whom he called Eva, Picasso moved into the new area of Montparnasse, which soon became a chic artists' district. Kahnweiler offered him a contract. At 33, Picasso was now a successful, well-paid painter. In the spring of 1914, his painting *Acrobats* was sold at auction for 1,500 francs. But fate cast another dark shadow that same year:

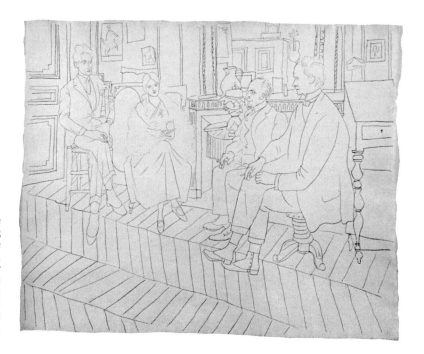

A drawing of the Picassos' living room in the Rue de la Boétie (1919), where the floor looks like one of the optical illusions devised by the physicist Ernst Mach.

his father José Ruiz died, to be followed shortly after by Picasso's beloved Eva, who died of cancer. And in August, World War I broke out, and the group of friends broke up.

The Road to Fame

During World War I, Picasso lived alone in Paris, in a small house in Montrouge on the edge of the city. His friends were called up, and Apollinaire and Braque subsequently suffered serious head injuries at the front. Only Max Jacob remained in Paris, though suffering from a mystic exaltation that took him, despite being Jewish, to the verge of Catholic monasticism. He was baptized a Christian in the winter of 1915, with Picasso as his godfather. During the war, only one acquaintance turned up frequently when on home leave: the young writer Jean Cocteau, who in early 1917 asked Picasso if he'd like to work on Diaghilev's new ballet. Picasso accepted, and in February that year set off for Rome, where Diaghilev's ballet company was at the time. Rome was a revelation after the dark war years in Paris. Dazzled, Picasso roamed through the city gazing at classical art as if intoxicated. He discovered classical sculpture, and could not get enough of Michelangelo and Raphael. In Rome he also met a young Russian dancer, Olga Khokhlova, who followed

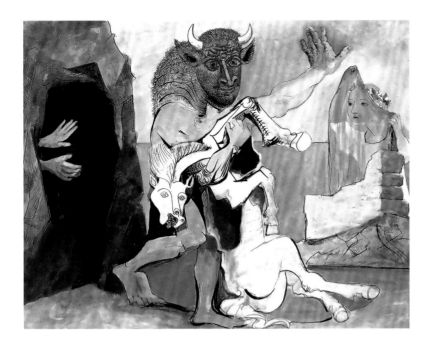

The figure of the Minotaur stands for the artist's aggressive creative urge (1936).

the painter home to his family in Spain. The following year they got married, with Cocteau as best man. The ballet (*Parade*, premiered in Paris on 17 May 1917) did not command rave reviews. What with the music of Eric Satie and the abstract figures designed by Picasso and Cocteau, it was too avant-garde. Apollinaire's phrase for the absurdities of Parade ("a sort of *surréalisme*") introduced a new term to art that would characterize a whole school of artists. Unfortunately, Apollinaire himself was not around to see the new style, succumbing to Spanish flu in 1918.

Picasso and Olga moved into a large two-floor apartment in the Rue de la Boétie. It was a radical change of lifestyle. Picasso now wore a suit and hat and went about with a walking stick. Olga ran the weekend *salon* to which the whole of Paris came. Picasso had to set up his studio on the floor above so as to be able to work undisturbed.

He began to paint again, but this time in an academic, classical style, perhaps under the influence of his Roman experiences, possibly also responding to the general desire in the 1920s, felt by many artists who returned to a neo-classical style, for a "return to order" after the radical developments of the previous decades.

Picasso was also obliged to change dealers during the war. As Kahnweiler was German, he had to leave the country and his busi-

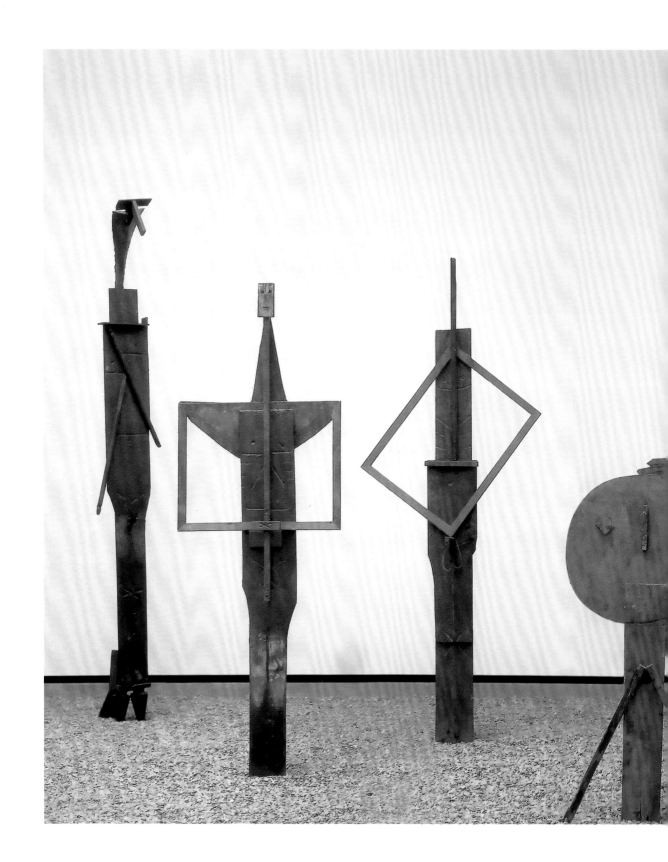

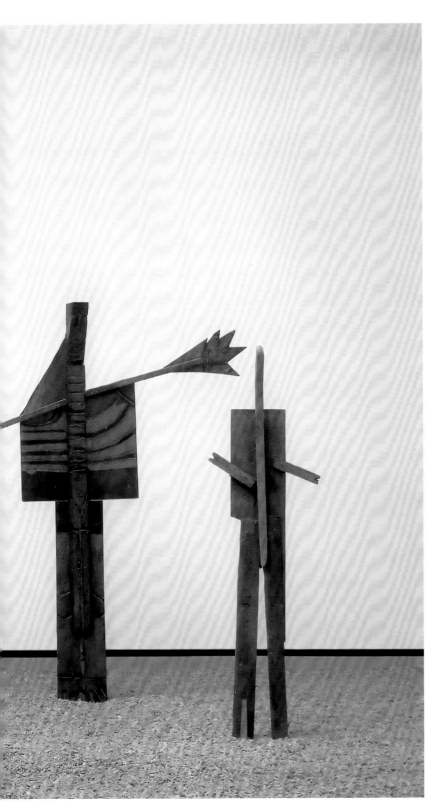

LOOKING BACK
The large figure group Bathers (1956) was another virtuoso demonstration of what assemblage and montage had to offer, techniques Picasso had already investigated in Synthetic Cubism. The subject matter of the *Bathers* also goes back to works from the 1920s. Picasso exploited his own art like a treasure trove whose stocks appear inexhaustible in their combination and variation. The visual wit of the figures becomes evident only on closer inspection.

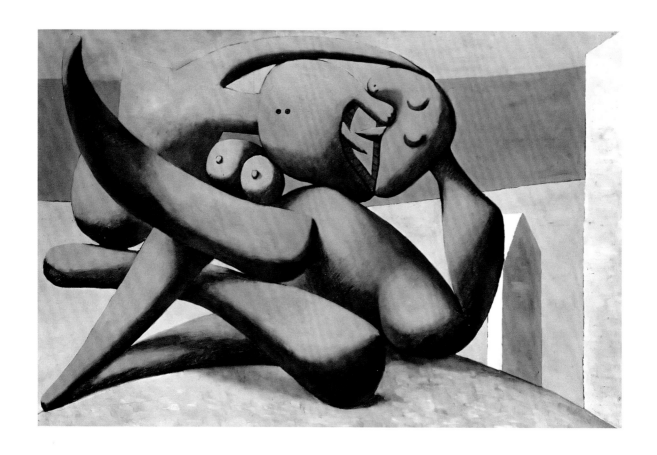

SEXUALITY AND AGRESSION
In the 1930s, Picasso created an obscure universe of figures that seem to be fighting and devouring each other during sex. The aggressiveness in these scenes may be due to Picasso reading Surrealist writings, as the French writer Georges Bataille claims, or to his deep dissatisfaction with his own love life (b/w reproduction).

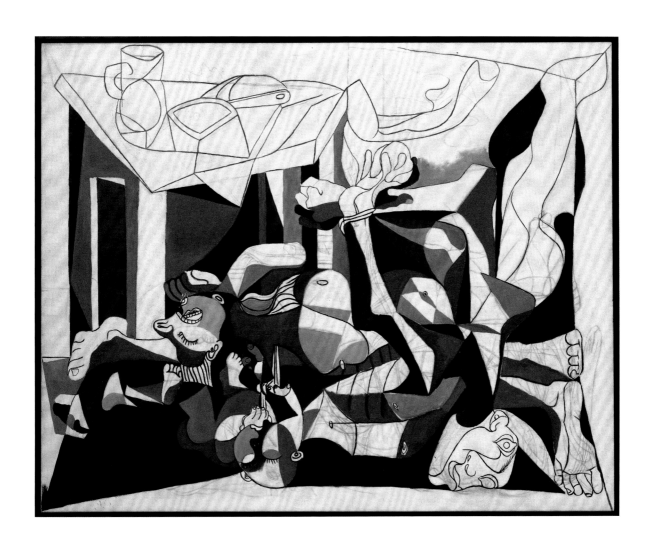

CRIMES OF WAR
Picasso never saw himself as a political artist, though after *Guernica* he was appropriated by the Communist Party. Towards the end of World War II, however, he did paint one other large picture in which he sought to treat the terrible crimes in German concentration camps (1945).

ness was shut down, so that from 1918 Paul Rosenberg represented the now successful artist. Criticism of his change of style left the artist unmoved; he went on producing work in Cubist and figurative styles, and selling both at high prices.

■ The Minotaur Awakes

But Picasso began to feel increasingly ill at ease in a middle-class environment, with the endless parties, receptions and balls that Olga kept taking him to. The birth of their son Paulo changed nothing. Though he adored the boy, Picasso still found being a father and provider a burden.

His growing impatience and aggression towards his family expressed itself overtly in his new works, which are notable for what seems like an unbridled pleasure in dismembering and deforming the figures. It is debatable whether Surrealism, which dominated the Parisian art scene from 1925, had any part in this development. Though he was on good terms with leading figures of the Surrealist group, it was mainly with poets and writers such as Paul Éluard, Louis Aragon, and Robert Desnos, not artists. In his paintings, drawings, and the burgeoning output of etchings, a monster now kept appearing—the Minotaur, the raging destroyer that can

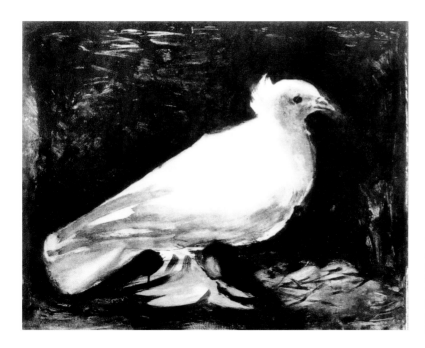

The dove image was used for the poster of the World Peace Congress in Paris in 1949, and became the best-known peace symbol of the postwar period.

be pacified only by the muse, sometimes by a woman, sometimes by a child holding a candle.

Picasso's sculptures got the same treatment, like the Bathers (pp. 74–76) for example, who appear to be in a trance after the fury of their creation from roughly assembled wooden planks. There is in this more than a passing likeness to the African totems and sculptures that Picasso collected and kept in his studio.

From 1930, Picasso worked on sculptures at Château Boisgeloup, his country estate south of Gisors. After 17 years of marriage he left his wife, though divorce proceedings were never finally concluded. A new face now appears in his paintings and sculptures, young, round and with long blond hair: it's that of Marie-Thérèse Walter, who became Picasso's lover in 1931. In 1935, she gave him a daughter, Maya.

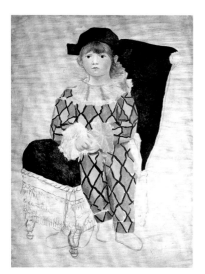

In the early days a devoted and adoring father, Picasso often painted his son Paulo (1924).

▮ The Art of War

In 1936, Civil War broke out in Spain. Picasso supported the Republicans, painting the famous *Guernica* for them (pp. 56–57). A powerful denunciation of the horrors of war, it is perhaps his best-known painting.

The long years of World War II were difficult and dangerous. Picasso lived with his secretary Jaime Sabartés, a friend from his Spanish days, in a new studio at no. 7 Rue des Grand-Augustins. German officers ransacked his apartment time and again, rummaging through his pictures. One day they discovered a photo of *Guernica* and asked: "Did you do that?" Picasso acidly replied: "No, you did."

The relationship with Marie-Thérèse was finally broken off, to be replaced by one with Yugoslav photographer Dora Maar, who could talk to Picasso in his mother tongue and kept her own end up in long talks about art. But their relationship was strained, and always overshadowed by her scenes of hysterical jealousy, the prime inspiration of Picasso's *Weeping Woman* series.

After the Liberation, Picasso joined the Communist Party, which immediately harnessed him for propaganda purposes. His lithograph with the dove of peace, the counterpart to his *Guernica*, also achieved worldwide fame. Later he resigned from the Party when he noticed that he was supposed to shine only at party conferences.

His paintings contain no direct political attitude or reflections on war or the famine in Paris. Towards the end of World War II, he painted *Charnel House*, in which he sought to deal with his impressions of American photos of liberated German concentration camps (p. 77). However, the artistic reworking involved filtered out any direct political expression. The *Massacre in Korea* (1951, p. 78) some years later related to the Korean War, which had begun half a year earlier. Here the message is more obvious, with the figures clearly divided into good and evil: the four naked women rigid with fear on one side, the soldiers shooting them on the other. His indignation at the Korean War prompted him to convert an abandoned 14th-century chapel in Vallauris into a temple of peace, decorated with two large murals on the subjects of war and peace.

In the fall of 1945, Picasso got to know the book printer Fernand Mourlot, who encouraged him to take up print making again. And once more a new face appeared on the first lithograph: that of Françoise Gilot, a young art student who, after initial hesitation, started an affair with the now 64-year-old artist. It would last ten years and produce two children, Claude and Paloma.

▬ Quiet Days in Mougins

The villa La Californie is in the village of Mougins, behind Cannes in the south of France. Picasso retired to its light, airy rooms in 1955. That was two years after Françoise had left him, the first woman to do so—and the first not to go to pieces after their relationship ended. The difficult times now seemed past: the press treated Picasso like a film star and followed wherever he went. In La Californie he found the quiet he needed to work. He was already 74 and living with Jacqueline Roque, a Provençal beauty he had met in the pottery village of Vallauris.

La Californie was crammed full of pictures from all periods, as well as sculptures such as Goat, which was installed in the garden, where it acquired a patina from doves and Picasso's dogs it would never have had in a museum! Apart from Kahnweiler and Cocteau from Paris, his new circle of friends consisted of bullfighters, photographers, printers, and potters, who were solidly earthbound and who communicated a new feeling for life.

That same summer, filmmaker Henri-Georges Clouzot made a celebrated film about Picasso showing him at work, enabling audiences to see the process that went into making a picture. Picasso was enthusiastic about the film. He had just finished a series of 15 paintings, variations of Delacroix's *Women of Algiers*. Asked why he did so many studies, he replied: "It's the way I paint, doing such a large number of studies. I do hundreds of studies in a few days, whereas other painters might spend a hundred days with one picture. I throw the windows open when I work. I get behind the canvas, and sometimes something new comes out of it."

The rich Art Nouveau decoration of the building, and the garden with its palms and eucalyptus trees, stimulated Picasso into painting a series of very decorative works reflecting the spirit of his friend and rival Henri Matisse, who had died in November 1954. In the final years, the two elderly painters frequently exchanged visits and traded stories. In old age, Picasso became gracious towards his old rival, and often used to say: "Basically, there's only Matisse." Picasso himself now made more of color, introducing more intense contrasts between the primary colors red, blue, and yellow.

In September 1958, Picasso took over Château Vauvenargues, which was situated on the north slope of Mont Saint-Victoire. Here he was close to his idol Paul Cézanne. "I'm living with Cézanne," he once said mischievously.

On 14 March 1961, Picasso's marriage to Jacqueline made the headlines, though even close friends had known nothing of it

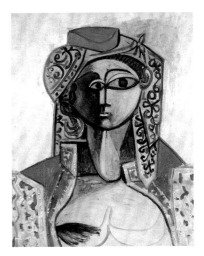

Picasso's second wife Jacqueline Roque in Turkish dress (1955).

beforehand. Jacqueline, who was almost 50 years his junior, accompanied him like a shadow, putting up with his whims and bad moods to the point of self-denial. But there was a tacit agreement between them: Jacqueline was quite able to hold her own in talking about his work, managing the household, and being a charming, attentive hostess. One portrait of her is called *Jacqueline, My Queen!*, and that was no exaggeration for Picasso. He was more than ever reliant on her assistance, because age exacted its tribute even from him. After a serious stomach operation, he was no longer allowed to smoke, and had to be careful about what he ate and drank. His eyesight deteriorated, so that he had to conceal his notoriously penetrating gaze behind thick glasses. His increasing deafness often prompted him to avoid company and to welcome visitors only reluctantly.

But his imagination was undimmed. What health denied him, he now projected onto his canvases, prints and drawings, wild erotic scenes that often border on the pornographic and that brought him the illusion of boundless male potency.

The harsh climate of Saint-Victoire and the cold rooms of the château were not suitable for year-round work, so in 1961, Picasso bought a house in Provence called Notre-Dame-de-Vie, near Mougins. It was off the beaten track, but not remote, being about eight kilometers (five miles) from Cannes. Shortly before his death, Picasso drew a last self-portrait. Of all his late works, this is the most realistic portrait, showing the emaciated features of the old man, the characteristic nose, and the wide-open eyes, not fixed on the viewer this time to challenge and defeat, but wide with the fear of imminent death.

On 8 April 1973, Picasso died in his villa of Notre-Dame-de-Vie at the age of 91, following a persistent bout of flu, and was buried two days later in his garden at Vauvenargues. His children remained long in dispute about the vast estate, and it was only in 1977 that an agreement was reached between the three children, Maya, Claude and Paloma; the two grandsons from the two marriages of his son Paulo, who had died in an accident in 1975; and his widow Jacqueline. As 20 percent of his vast estate was due to the state in inheritance tax, this was paid in art works, which formed the basis of the Musée Picasso, opened in Paris in 1985. Jacqueline also donated the private collection of pictures by famous French painters to the state.

For 13 years, Jacqueline made her pilgrimages to the tomb of Picasso in the park at Vauvenargues. On the last occasion, on the 15 October 1986, aged 59, she shot herself there.

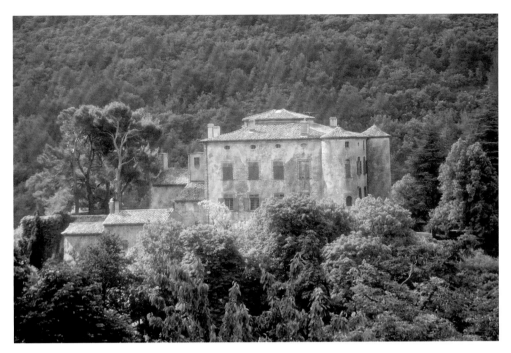

Picasso's Château Vauvenargues, on the northern
slope of Mont Saint-Victoire.

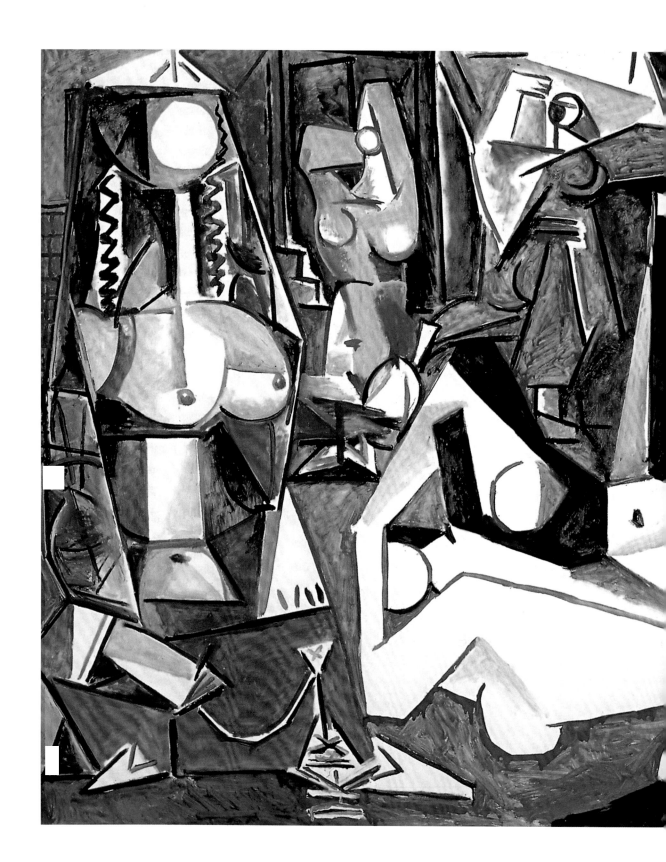

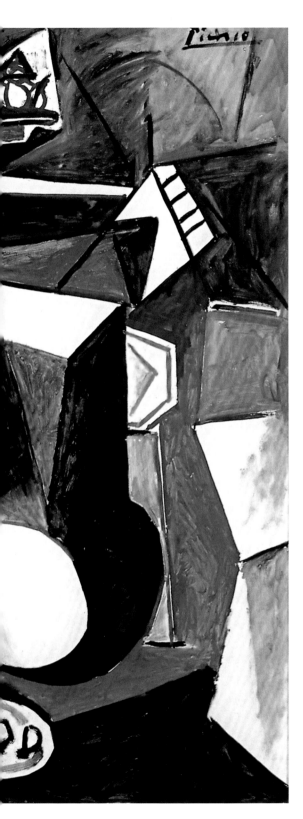

THE WOMEN OF ALGIERS
In the 1950s, Picasso often took works by earlier painters as a basis, to be worked up in a new style. Delacroix's famous *Women of Algiers* is here transformed into a strictly articulated composition of angular shapes. The work was preceded by numerous studies, during which various alternative treatments were explored.

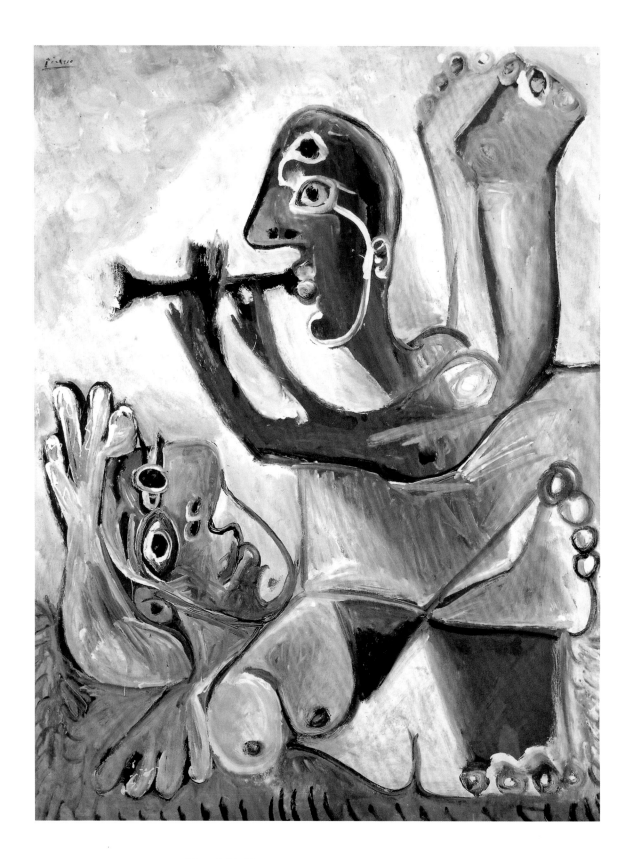

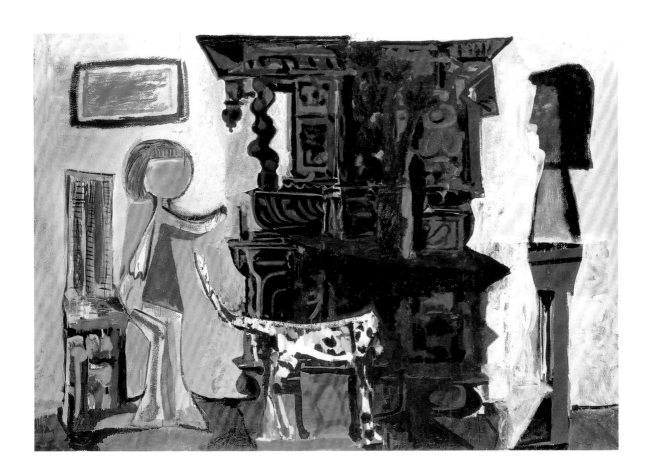

NEW COLORS
Any reticence in the use of color has been abandoned. Picasso invents more and more new combinations to rival his old friend Matisse. *The Dresser at Vauvenargues* (1960) is a good example.

left
THE WILD OLD MAN
Picasso's late works, like *Aubade* (1967), are characterized by impetuous, violent brushwork and "muddy" colors. But the pleasure in painting is still very evident.

Love

Brassaï

"FOREVER DESIRING, FOREVER
WEARY OF HIS CONQUESTS
LIKE THE GREAT TRICKSTER OF
SEVILLE [DON JUAN], HE AL-
WAYS SUBJECTED HIMSELF TO
JUST A SINGLE WOMAN, ONLY
TO LIBERATE HIMSELF FROM
HER THROUGH HIS WORKS."

SPOTS

Picasso's relationship with women was varied and contradictory. Alongside countless dalliances with models and casual lovers, he also had intense relationships with women who attracted him for their beauty and intelligence. But basically he was incapable of love, demanding that women submit to him completely. For Picasso, women meant both mystery and martyrdom—but also something he could never escape

Picasso and His Children

Picasso painted his children many times, especially as infants in a "state of innocence." Once they grew up, his interest waned. But these portraits and mother-child

Some of Picasso's happiest images are of children—here of a child absorbed in a game.

pictures in particular reflect his nature, his love, and attachment. They stand out like calm islands amid the problematic and difficult works, representing an idyll that probably never existed. More than three-quarters of the pictures about children from the early 1920s onwards are devoted to his own children: Paulo (b. 1921), Maya (b. 1935), Claude (b. 1947), and Paloma (b. 1949). He observed their childish behavior with fascination, since it had a degree of wildness and spontaneity to it. Once the children reached puberty, the portraits ceased, and the family album was closed and no longer made public.

The Most Beautiful

All Picasso's women and lovers had distinctive qualities, whether in their external appearance or their outstanding intelligence. But none was so beautiful and captivating as Marie-Thérèse Walther (above). Her rival Françoise Gilot did not begrudge her this beauty: "She was not an insistent reality, she was a reflection of the cosmos. When it was a fine day, the clear blue sky reminded him of her eyes. For him, the flight of a bird embodied their relationship. And over a period of eight

or nine years this proud idea invested many of his paintings, sculptures and etchings. The light of perfection rested her on her exquisite body."

Eros and Thanatos (Love and Death)

Despite his enduring search for women, Picasso harbored a deep fear of them, no doubt a vestige of his Spanish origins. Early on, he came to appreciate the conflict between the macho element that oppresses and dominates, and the devoted slave of love helpless in the face of his sexual drive. That's why Picasso the atheist was also reported to have deeply rooted superstitions, fed by his

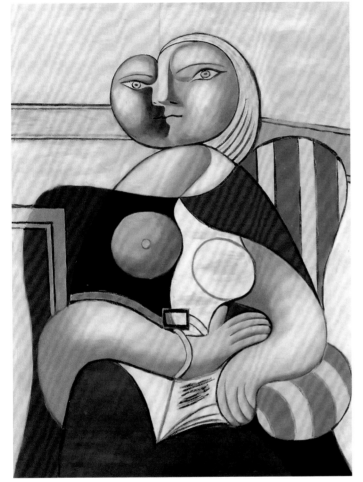

Women ...

... dominated Picasso's life from the first, and even in childhood and youth he was cared for and brought up by women.

... were the inspiration for most of his works.

... were attracted to Picasso despite his macho manner and difficult behavior.

Spanish acquaintances and also by his Russian wife, Olga.

"The Secret Eye"

Picasso revealed his "secret eye" in many erotic drawings. This passion linked him with Apollinaire, who made money by publishing pornographic books. The latter's bibliography of pornographic literature in the *Bibliothèque Nationale* in Paris is now considered a standard work. Apollinaire himself published a work of pornography called *Les Onze Milles Verges* ("11,000 Penises").

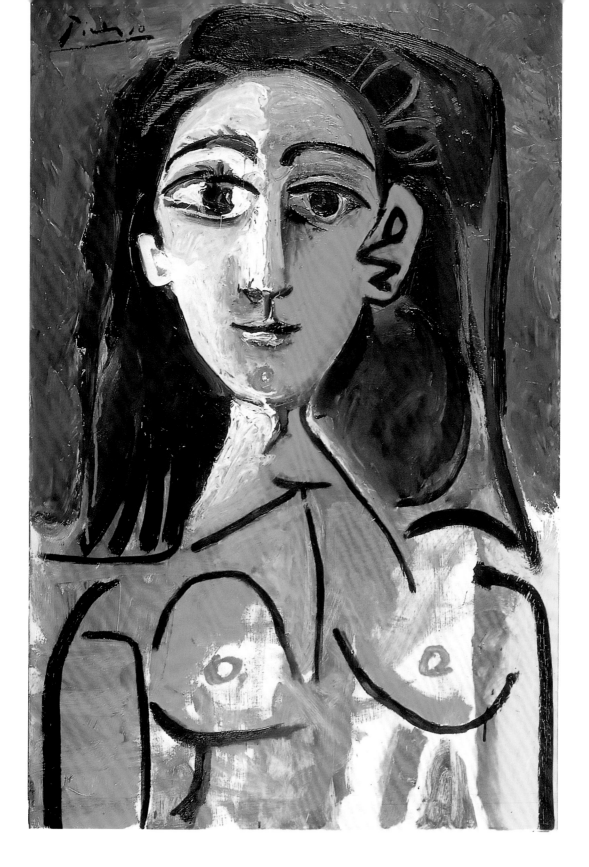

Muses, Mistresses, and Madonnas

For Picasso, women were the indispensable source of his life force. Without a woman at his side, even if only for a short while, he was incapable of fully expressing his genius. But his love for women was not selfless and self-sacrificing. It was overbearing, dominating, and demanding. Along with beauty and intelligence, total devotion and submissiveness were preconditions of a relationship. But buried deep under the Spanish machismo *there lay fears and complexes that made his affairs complicated and troubled.*

▬ Fernande and the Bateau Lavoir

Before Fernande Olivier (1881–1966) embarked on a relationship with Picasso, she had been the model and lover of several other artists in Montmartre. She described her first encounter with Picasso in her memoirs, *Picasso et ses amis* (1933): "He was not particularly seductive if you didn't know him. Of course, his strangely piercing gaze commanded attention. You could not guess where he was from, but this glow, this inner fire you sensed in him lent him a kind of magnetism I did not resist. And when he wanted to get to know me, I wanted it, too."

left
Jacqueline Roque was Picasso's partner during his final years.

In contrast to Picasso, who was stocky and thickset, la Belle Fernande was tall, red-haired, and beautiful, a striking phenomenon in the bohemian circles she moved in. Though their affair began shortly after their first meeting, in the summer of 1904, it was not until a year later, during the summer of 1905, that she decided to move in with Picasso, who was then living in the Bateau Lavoir.

The early years were notable for hardships, but they were also filled with great passion and joy. Picasso was really in love for the first time in his life and, in keeping with his Spanish machismo, intensely jealous. This morbid jealousy was so powerful that he took to locking her into the dirty studio when he went shopping or out with friends. Fernande put up with it as long as she had a supply of tea and books. She passed the time with a little housework interspersed with long breaks.

In the lean years, when as often as not they did not have enough coal for the stove, the two of them improvised with tricks and petty swindles. They would for example order food from the patisserie on credit and have it sent to the Bateau Lavoir, but then didn't answer when the doorbell rang. Only when the delivery boy had gone did they tuck in, paying, if at all, some weeks later. Even though many things are transfigured in Fernande's account, her memoirs of the

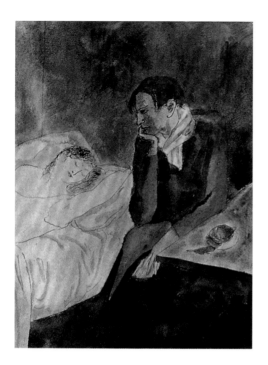

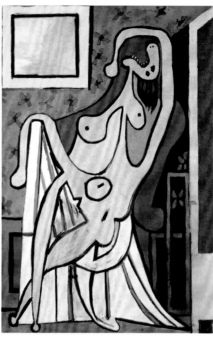

Bateau Lavoir years read as if it were one long, happy period overshadowed by only minor financial problems. If Picasso sold something to dealers like Clovis Sagot or Ambroise Vollard, they invited friends round, or met up with them in the small cafés on the Butte. Highpoints of the week were the "verse and prose" Tuesday evenings at the famous *Closerie des Lilas* café in Montparnasse. To these famous Tuesday soirées came poets, writers, painters, sculptors, and musicians—such as Symbolist Jean Moréas, scourge of the middle classes Alfred Jarry, Gustave Kahn, André Salmon, Guillaume Apollinaire, Maurice Raynal, Georges Braque, Picasso and many others whose names are lost in history. Fernande also openly describes evenings when opium and hashish were consumed. Such excesses came to an abrupt end, however, when a German painter hanged himself in a neighboring studio after one of these evening.

Over the years, the intensity of their passion gradually waned, but the break came only after a move to a new studio apartment in Boulevard de Clichy in 1909. Picasso's star was rising, Cubism had become his life, and it changed that of the beautiful Fernande for ever.

Fernande was the first of seven women in Picasso's life who noticeably influenced his work as lovers or wives. She saw at

firsthand the birth both of a genius and of the Picasso myth. And she shared with him perhaps the finest period of love in his whole life. After a number of "wild years" during which she worked as a singer at the *Lapin Agile*, as a private tutor, secretary, cashier, manager of a cabaret, and finally a writer of horoscopes, in 1918—the year Picasso married his first wife, Olga—she began living with the film actor Roger Karl.

▬ *Eva:* Ma Jolie

In May 1912, Picasso painted a picture called *Ma Jolie*. It was a declaration of love to a new lover, Eva Gouel (1885–1915), whose real name was Marcelle Humbert and who was the focus of Picasso's passion for only a few years: she died of cancer in late 1915. When she discovered this long-hidden relationship, Fernande left with a Futurist painter called Ubaldo Oppi, abandoning him soon after.

Picasso meantime moved in to a spacious new studio in Rue Schoelcher overlooking Montparnasse cemetery. In the months during which Eva waited for death in a hospital in Auteuil, Picasso sought consolation in fleeting liaisons, for example with 22-year-old Parisian Gaby Lespinasse, though because of the brevity of the affair she did not feature in any of his pictures. Another was his neighbor and confidante in Rue Schoelcher, Irène Lagut.

▬ Olga and the Theater of Love

When Picasso accepted an invitation to Rome from impresario Sergei Diaghilev in 1916, and so joined the Ballets Russes there as a set designer, he was overwhelmed by the vibrant, sun-drenched city, with its Baroque buildings and wonderful churches in which marble statues gleamed in mysterious shadows.

The light and life of the city certainly contributed to Picasso's new experience of love. This was with Olga Khokhlova (1891–1955), one of Diaghilev's *corps de ballet* and a daughter of a colonel in the Russian army. The ballet later moved on to Barcelona, where Picasso painted a wonderful portrait of Olga in a naturalistic style that underlined her classical beauty (p. 71).

When the Ballets Russes left Barcelona to tour South America, Olga remained behind with Picasso. In the fall of 1917, the couple returned to Paris together and moved into a small house in Montrouge. On 12 July 1918, they got married in the Russian church in Rue

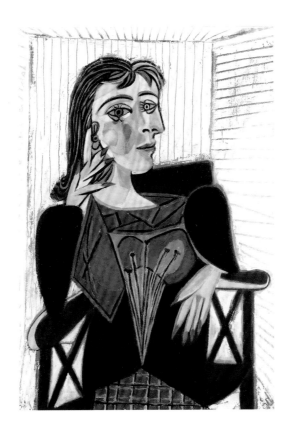

Daru, with Apollinaire, Jean Cocteau, and Max Jacob as witnesses. Straight after the wedding, they moved into a two-story apartment in Rue de la Boétie. Olga loved the smart life. From a well-to-do family, she had inherited middle-class tastes and furnished the apartment with expensive furniture and fine bric-à-brac. Picasso preferred to set himself up on the second floor, where he could paint undisturbed. They were now moving in Paris's top social circles, and for a while Picasso accepted this new lifestyle, not least because of the birth of their first son, Paulo (also called Paul), on 21 February 1921. The

above
The relationship with photographer Dora Maar, despite her challenging intelligence, was emotionally problematic (1937).

The *Vollard Suite*, produced by Picasso for publisher and dealer Ambroise Vollard between 1930 and 1937, comprises one hundred etchings. The bust at the center of attention has the portrait features of Marie-Thérèse.

same year, Picasso leased a large, comfortable villa in Fontainebleau. But their relationship became increasingly uneasy. Though Picasso was proud of his new role as father of the family, it did not make him entirely happy. While he took a lively interest in his son's development, as the many paintings and drawings of Paulo prove, he left out the family scenes reflecting typical domestic life. Through his son, he in effect re-enacted the Rose Period: Paulo was dressed up in all sorts of guises and painted riding on a donkey, as Harlequin, as Pierrot, or as a torero. In his art he backed away from everyday reality so as to avoid the ever more modish lifestyle in which he had become trapped. The alienation between him and Olga, who was not able to appreciate his art, also put an end to the series of pictures he had devoted to his son. From 1925, a long suppressed cry for freedom burst out of Picasso in Surrealist images such as *Dance* (p.30).

"You have an interesting face, mademoiselle"

While out strolling one cold day in January 1927, Picasso came across a young woman in the vicinity of the Galeries Lafayette. This was 17-year-old Marie-Thérèse Walter (1909–1977), who didn't catch his name initially. Picasso immediately fell in love with her, and she became the model of his next pictures. She then rented a flat in the vicinity of the Rue de la Boétie. For the next few years, Picasso tried to keep the relationship secret, but her presence became more and more obvious in his pictures and sculptures. Her face, her body and his love inspired the beautifully curved lines of his drawings and the full shapes of the sculptures. The opulent forms of his lover constantly recur in the etchings of the *Vollard Suite*, lending his new neo-classical style expressive force and vitality. In September 1935, Marie-Thérèse brought their daughter Maya into the world, who also became the subject of several paintings.

But it was a difficult time in Picasso's life. The disagreements with Olga had become unbearable. In June 1935, Picasso failed to go on holiday with his family for the first time. Olga would never go back to him. Because of property complications, divorce was out of the question. By way of compensation, Olga was given Château Boisgeloup and the flat in Paris. She died, unreconciled and embittered, in 1955.

Picasso left Marie-Thérèse in 1943, but remained in contact with her and their daughter to the end of his life. In 1977, four years after Picasso's death, she killed herself. She no longer had the focal point of her life.

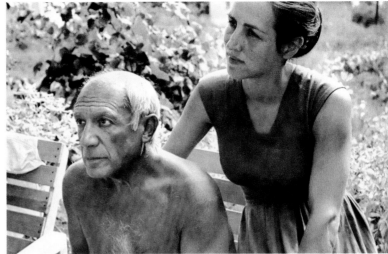

left
Françoise Gilot was a strong, self-confident woman who, despite her initial fascination with Picasso's personality, never surrendered her free will.

right
Picasso's work acquired new vigor from his relationship with Françoise Gilot, which in turn also greatly stimulated Gilot herself as a painter.

Dora: The Weeping Woman

Picasso's encounter with the Yugoslav photographer Dora Maar (1907–1997) in 1936 made things still more complicated. She was a mature, charming woman and could discuss art in his own language for hours. The presence of both Marie-Thérèse and Dora is seen in the art of this period. In many of the portraits of the 1930s, both faces appear, in others only one of the women is present. Dora Maar was the unhappier of the two, and was the direct inspiration of the *Weeping Woman* series.

Picasso's pictures of women painted during the war display deformation and fear. The destruction of the human portrait was sometimes offset, however, by compositions featuring a double countenance.

Picasso was searching for the original unity beyond destruction, as is shown in the archaic picture of the Great Mother or in

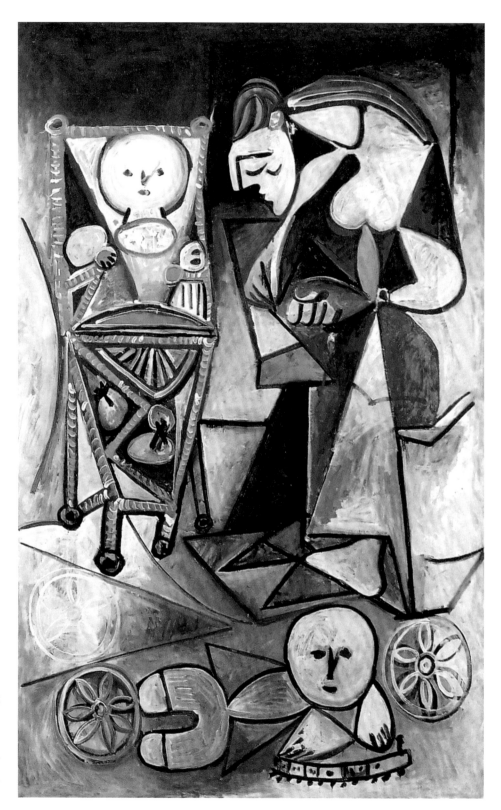

FAMILY PICTURE
Formally impressive,
*Woman Drawing
beside Her Children*
(1950) confirms that
Françoise's enthusiasm
for art had not abated,
and despite her
maternal duties she
took every opportunity
to work at it.

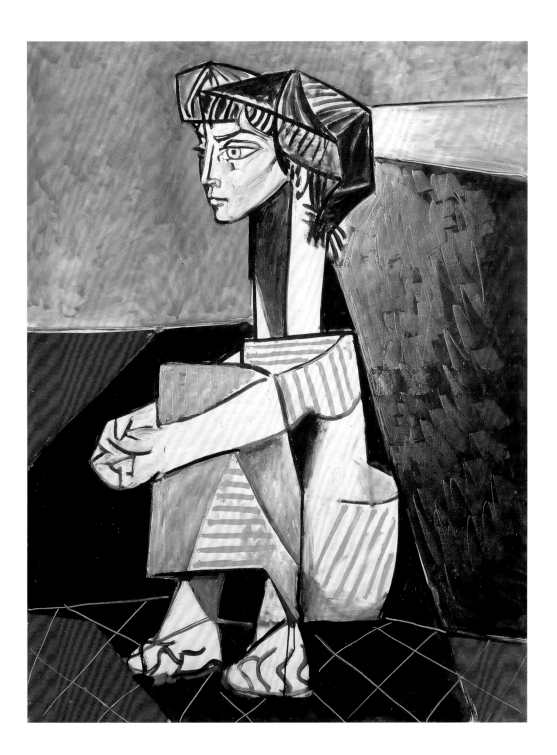

HIS LAST PARTNER
The angular profile of Jacqueline Roque is found on whole series of portraits in the 1950s, as in this portrait, *Jacqueline Roque Sitting Clasping Her Knees* (1954).

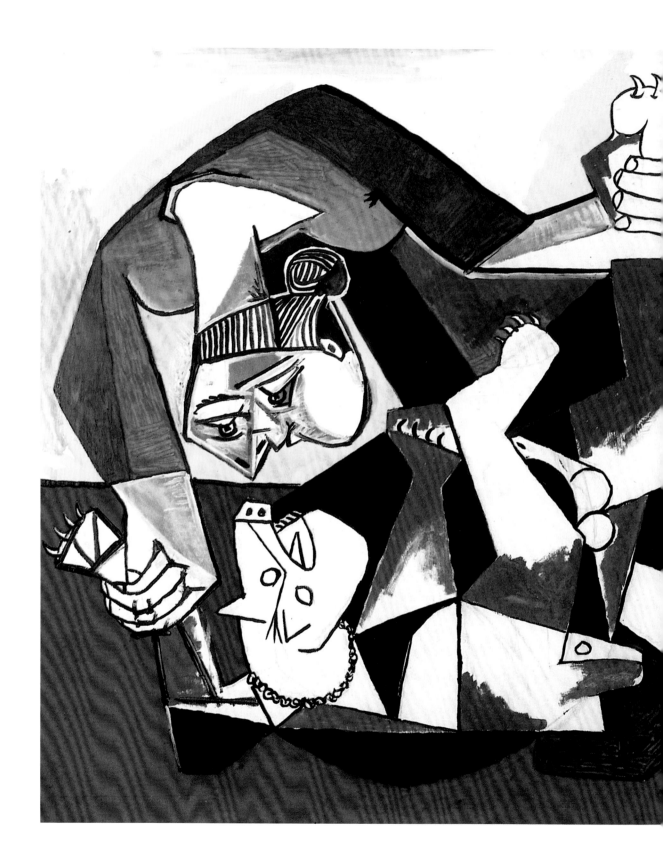

WOMAN PLAYING WITH DOG
The harmless game with a dog becomes in Picasso's picture an allegory of the fight between two polarities of life, Eros and Thanatos, the power of love and the cruelty of death (1953).

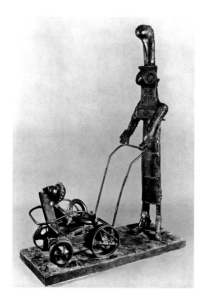

Picasso's inventiveness knew no limits. Using found objects and his children's toys, he assembled a model for his bronze sculptures (1950).

the hermaphroditic unity of the sexes conjured up by the Surrealists. But he could also give women threatening features, as in his series of *Bathers*, in which the figures often resemble fearful insects more than women bathing. Picasso invested these portraits of women with the magic vividness of Christian Madonnas or archaic idols. The destructive force of the Great Mother is shown, as is the dominant, conciliatory force of a primeval image of woman, which, particularly in the societies of the Mediterranean region, is seen as the origin and guarantee of order.

Dora Maar was unable to cope with the tension for long, and required psychiatric treatment for depression. This became a prolonged period of analysis with the celebrated psychoanalyst Jacques Lacan, who was a friend of Picasso's. From 1945, she lived in a house in Ménerbes that Picasso bought her. The sporadic contact between them continued until his death.

▬ Françoise and the Mediterranean Idyll

Françoise Gilot's (b. 1921) story of her life with Picasso is one of the most interesting and penetrating accounts of the artist's psyche. She first met him in 1943 in the *Le Catalan* restaurant in Paris as a young 21-year-old art student. He was with friends, including his then current lover Dora Maar. Picasso noticed Françoise and her friend sitting at a neighboring table and offered them a bowl of cherries. When they naively introduced themselves as "painters," he let out a roar of laughter, but nonetheless invited them to his studio in Rue des Grands-Augustins. Out of this came, hesitantly at first and with several interruptions, one of the most intense love relationships Picasso ever had.

After the liberation of Paris at the end of World War II, they moved into a house in Golfe-Juan on the Mediterranean coast, which at the time was still free of tourists. Picasso was offered a large room in the old Château Grimaldi in Antibes as a studio. There was still plenty of time between painting and sculptural work for carefree hours on the beach, hours of harmony and happiness, though they were overshadowed time and again by surprise visits by Olga. Violent altercations ensued between Picasso and Olga. She was still jealous of all Picasso's women, but especially of Françoise, in whose keen intelligence she sensed a real rival.

The relationships with Dora Maar and Marie-Thérèse Walter continued to drag along in the background. Picasso took whole "days off," notably to see Marie-Thérèse and Maya in Paris. Noth-

ing really changed when Françoise became pregnant with Claude. Though Picasso was pleased to have demonstrated his virility once again, he was no better a father this time either.

Françoise later wrote candidly: "All these carryings-on and reminders of Olga, Marie-Thérèse and Dora Maar, and their constant behind-the-scene presence in our life, gradually convinced me that they were the expression of a Bluebeard complex that kindled in him a desire to exhibit in a small private museum all these women he had collected. He did not cut their heads off completely. He preferred life to go on. These women who had shared his life at some point were to let out feeble cheeps of pleasure and pain and move spasmodically like broken dolls, enough to prove there was still a breath of life in them, a life that hung by a thread which he held in his hand. From time to time, they lent events a happy, dramatic or tragic gloss, and that was grist to his mill."

The birth of a second child, their daughter Paloma, made no difference to the growing alienation between them, which was exacerbated by Picasso's outbreaks of rage and his amorous escapades. While Picasso immersed himself entirely in his work (which from 1948 chiefly meant pottery in Vallauris), Françoise was left to look after the children and household quite alone at the Villa La Galloise. On his return, she also had to satisfy his other needs, which included not only discussing all night long his work (and in the later years their relationship as well), but also lending a hand with his exhibitions. By 1952, she had made up her mind to leave him, but it took another two years before she could summon up the strength to do so. Finally, Picasso let her and the children go. But when he fully grasped the permanence of this step, he had all her possessions, her letters and books, her pictures and drawings in Villa La Galloise cleared away. Her contract with Kahnweiler was cancelled (for she too was an artist), and other dealers turned her down. For a long time, the name Picasso hung over her like a dark shadow. But Françoise Gilot was the only one of his women to shake off the shadow and create an independent life for herself—as a successful painter.

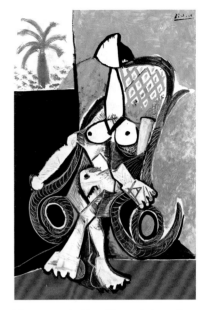

Picasso never let himself be carried away by the fashion for abstract painting. But in this painting the trend towards French Art Informel and American Abstract Expressionism seem to have left their marks (1956).

Jacqueline and Picasso's Last Years

In June 1954, Picasso painted in Vallauris two pictures of a mysterious new woman he called Madame Z. She was in fact the young sales assistant at the Madoura Pottery, Jacqueline Roque (1926–1986), who at the time lived in a small house between Golfe-

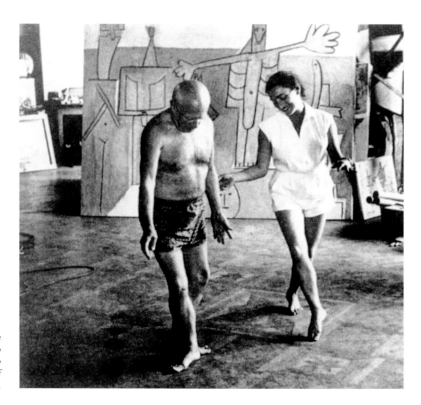

Jacqueline Roque showing Picasso a dance step in front of one of his works.

Juan and Juan les Pins. The house was called Le Ziquet, a Midi expression for "little goat." It seems that for a while Picasso shuttled back and forth between Françoise and Jacqueline so both would remain dependent on him. They even went out together, or met Jacqueline for a meal. But Picasso could not get over the separation from Françoise. After some unpleasant scenes, he dropped her completely and took Jacqueline as his new partner. In 1961 they were married in Vallauris, unbeknownst to friends and the media.

Picasso moved into a new villa near Cannes, La Californie, where he set up a large new studio. As if he wanted to draw a line under the past, he formed a new circle of friends consisting of bullfighters, printers, photographers, and potters. He was now 74 years old, and plunged into painting again, looked after by Jacqueline, who read his every wish. Jacqueline was a small, black-haired woman with southern-French looks and a temperament to match. She knew how to cook and do housework, but was just as capable of discussing art and artists with Picasso in Spanish. But chiefly she was a charming hostess who knew how to look after and entertain Picasso's guests.

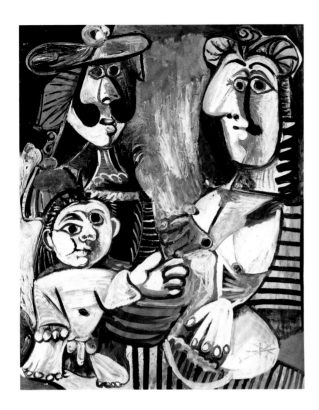

In his late works, Picasso revisited many earlier themes. This painting *The Family* dates from 1970.

Picasso sought to compensate for the decline in his health and especially his virility by painting more pictures. These works of his late oeuvre are conspicuous for their overt and explicit sexuality. Erotic scenes abound in Picasso's work, but they now became more common and more graphic, bordering on the pornographic. In the force of desire and creating, Picasso found his artistic potency again and again. A woman's body was the screen on which he could best project his male desire and creative passion; women constituted the motivating force of his work.

Jacqueline survived Picasso by 13 years, and during that time selflessly dealt with the complexities of Picasso's estate. On 15 October 1986, ten days before Picasso's 105th birthday, she took her own life on his tomb.

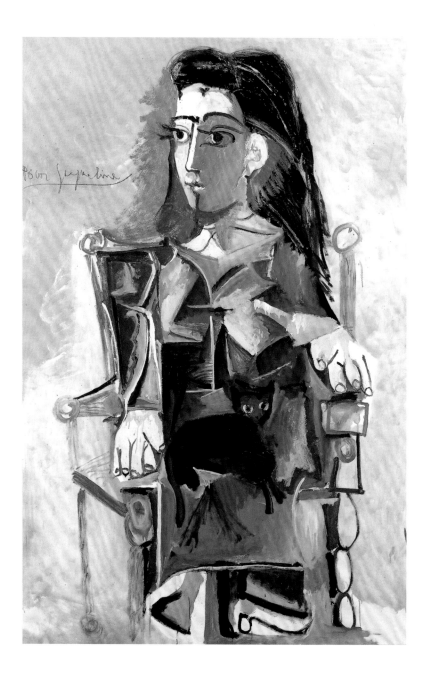

LOVELY JACQUELINE
This portrait of Jacqueline with a cat is different from the others of the period in showing her regular facial features almost naturalistically (1966).

right
IN PROFILE AND FRONTALLY
The almost classical-looking profile of Jacqueline shows once again Picasso playfully introducing Cubist features into the portraits of his late period (1963).

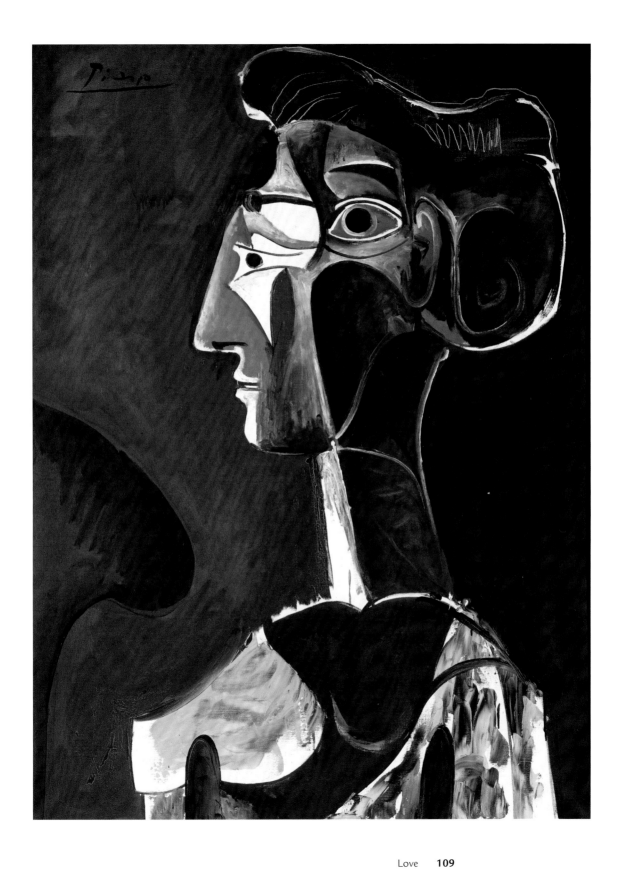

INDESTRUCTIBLE BEAUTY
This large, monumental nude (1964) with Jacqueline's
features dispenses with distortions and exaggerated propor-
tions in favor of the natural beauty of the female body.

THE FURY OF ART, OR LACK OF CARE?
The gestural style of the aging Picasso was criticized as waning vigor, but derived in fact from an unbridled passion for painting.

left
THE PAINTING ADVENTURE
Picasso's late pictures are populated by musketeers with pipes or feathers, a tribute to the adventure novels of Dumas, with an ironic nod in the direction of Rembrandt.

Picasso Today

Pablo Picasso

"SO WHAT IS AN ARTIST? … HE IS … A POLITICAL BEING, CONSTANTLY AWARE OF WHAT GOES ON IN THE WORLD, WHETHER IT BE HARROW-ING, BITTER, OR SWEET, AND HE CANNOT HELP BEING SHAPED BY IT. HOW WOULD IT BE POSSIBLE NOT TO TAKE AN INTEREST IN OTHER PEOPLE, AND TO WITHDRAW INTO AN IVORY TOWER FROM PARTICI-PATION IN THEIR EXISTENCE? NO, PAINTING IS NOT INTERIOR DECO-RATION. IT IS AN INSTRUMENT OF WAR FOR ATTACK AND DEFENSE AGAINST THE ENEMY."

SPOTS

As fascinated as ever the world has not lost interest in Picasso, in his paintings and prints, in his sculptures and pottery, and above all in his stormy life, which has been the subject of countless biographies and now a film. Though he was not the founder of a "school" in the traditional sense, artists of all kinds have drawn inspiration and ideas from his work. The "Picasso idiom" has even entered advertising and everyday culture.

Picasso's Late Works

When the first major commemorative exhibition after Picasso's death was put on at the Papal Palace in Avignon from May to September 1973, showing 201 paintings dating from 1970 to 1972, the art world was surprised and shocked by what seemed to be casual and hasty daubs always showing the same motifs: musketeers, women in all positions, and the perennial subject of the painter and his model. In addition, there were pictures and drawings manifesting an erotic obsession no one had even suspected of the elderly painter. Since then, the late oeuvre has been the subject of constant debate and controversy, notably by those using feminist and psychoanalytical approaches.

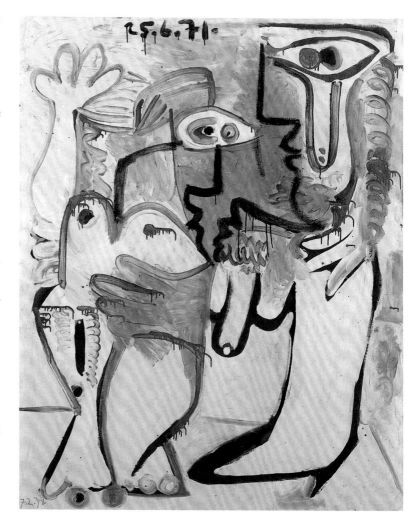

The most recent exhibition on Picasso's late works was *Painting Against Time*, presented by Werner Spies at K20 in Düsseldorf from 3 February to 28 May 2007.

Spies identified "two working speeds" in the late oeuvre—a rapid, almost gestural style in the paintings, and a slow, patient style in the drawings and prints: "This handling of time was to do with his character and restlessness. He was never concerned to produce definitive works. Variation was what he sought. Instead of working for months on a single work, he preferred to turn out another version. His restiveness merely grew in the

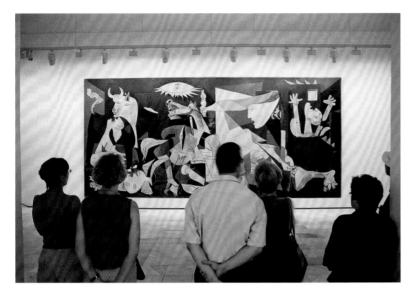

tant works from Picasso's private collection, transferred to the state in lieu of death duties in 1979. Since then, the Musée Picasso has regularly put on special exhibitions of its extensive collection, and undertakes research on his life and works.

late oeuvre. To formulate this in terms of pathos, you could say he was painting his own fear of death. Expressed metaphorically, he had an hourglass in his head, which he turned over every time he began something."

What Happened to Guernica?

Probably Picasso's most famous and highly praised, Guernica was first shown in 1937 at the World Fair in Paris. Later it went to the Museum of Modern Art in New York on permanent loan. However, under the terms of Picasso's will it passed into the ownership of the Prado in Madrid, to which it was transferred in 1981. The Prado placed it in the Casón del

Buen Retiro, a 17th-century palace on the eastern edge of Madrid.

The Musée Picasso in Paris

Probably the best-known of the many Picasso museums is the Musée Picasso, opened in the former Hôtel Salé in the Marais district of Paris in 1985. It possesses over 200 paintings, 191 sculptures, 85 ceramics, and over 3,000 drawings and prints. The basis of the collection was the package of impor-

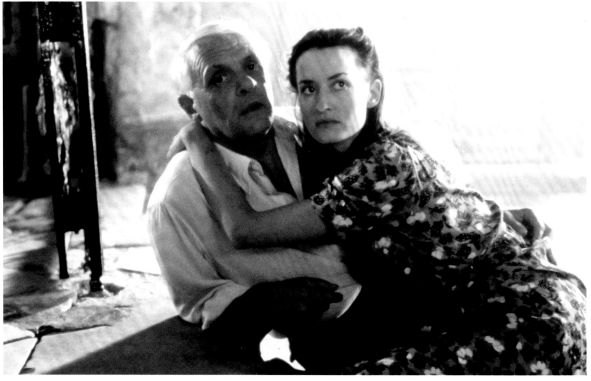

"The approval of future generations doesn't matter a jot to me. I've devoted my whole life to freedom and intend to go on being free, which means I don't even ask the dubious question, What will people say about me?" — Pablo Picasso

Picasso as a Myth

Even in his lifetime, there was a Picasso myth. Thanks to his longevity, his indestructible mental and physical vigor, and not least his numerous affairs, Picasso seemed immortal. He became a symbol of modern artists in general. Not much about this myth has changed even today.

Picasso as a Brand

Particularly in the 1980s, Picasso became a brand name, with his distinctive signature being used, as a gimmick, on ordinary consumer products, such as Citroen's *Picasso* range of cars, and Marino Picasso's *Picasso* perfume. Similarity of name was likewise exploited for promotional purposes. Aerosol artist Christian Chapiron for example called himself Kiki Picasso, and many people in the art world were taken in, thinking he was indeed a relative of Picasso's. But when the prankster tried to build himself into the family tree and eventually published a biography studded with invented "facts," the Picasso family took him to court and obtained an injunction against his using the family name. Kiki officially lost his pseudonym, though works bearing his name can still be found.

With the growth of the Internet, the use of Picasso's name has proliferated on thousands of websites. The official website handling Picasso matters (Picasso Administration) is www.picasso.fr, and provides the public and specialists alike with information.

left
Anthony Hopkins played the self-serving, sometimes cynical Picasso in his outstanding bravura role in the film *Surviving Picasso*. Torn between attachment and despair: Natascha McElhone as Françoise Gilot in *Surviving Picasso*.

Stefan Szczesny cites modernist masters from Matisse to Picasso in his strikingly colorful pictures (1982).

Picasso as an Inspiration

Picasso's late work continues to attract much interest from artists. In particular, the short-lived but vociferous Neue Wilden group of the 1980s were much influenced by it, notably Cologne-based painter Stefan Szczesny (b. 1951), who took up where classic modernism left off, borrowing motifs from Matisse and Picasso to produce a decorative style above.

In America during the same period, the Pattern & Decoration movement emerged. For example, decorative figuration and ornamentation were linked on the large-format canvases and fabric collages of Robert Kushner (b. 1949) and Robert R. Zakanitch (b. 1935), in which set pieces from pictures by Matisse, Cocteau, and Picasso are featured (p.121).

The Success and Failure of Picasso

An artist as rich, famous and successful as Picasso was inevitably open to criticism, which was often quite outspoken in his lifetime. Fellow painters such as Braque and Gris, for example, described the (by then) rich painter's bourgeois lifestyle, and his return to classical painting after the Cubist phase, as betrayals of art.

The most sustained and telling criticism of the artist, and of the dealers and others whom Picasso made use of thanks to his fame, has come from left-wing British art critic John Berger in *The Success and Failure of Picasso*. Berger was particularly critical of Picasso's method of fragmenting and distorting figures in his pictures, saying that where Picasso had found his subject, a series of masterpieces was the result, but where he had not, he painted pictures that

American Pattern & Decoration painting was one of the movements of the 1980s; the decorative aspects of Picasso's works are intential.

right above
ART HISTORY'S DREAM COUPLE
The stars of *Surviving Picasso* in an intimate
close-up. The likeness to Picasso was
emphasized by great acting, with Hopkins
catching the painter's mannerisms without
making an elderly eccentric of him.

right below
THE PAINTER POSE
Anthony Hopkins was impressive as Picasso.
However, he did not have to learn to paint—
the basics of the pictures were painted in
from the originals beforehand.

would later be considered absurd. Indeed, Berger thought they were already absurd at the time of writing (1965), only no one had the courage to say so lest they encouraged those elements of the middle classes who think that any art that is not a flattering reflection of their lives is worthless.

Surviving Picasso

Surviving Picasso, a Merchant-Ivory film that was premiered on 2 January 1997, focuses on the relationship between Picasso (played by Anthony Hopkins) and Françoise Gilot (Natascha McElhone). Director James Ivory's film concentrates mainly on the later years of the affair, and is set beside the Mediterranean. Ruth Prawer Jhabvala's screenplay was loosely based on Arianna Stassinopoulos Huffington's biography, and as Huffington's attitude to Picasso was feminist, Picasso is shown as a woman-hating, Spanish male chauvinist who not only constantly teases and annoys his lover and mother of his children Claude and Paloma, but also drives her into rages with his cruel mockery. Although Françoise had benefited a lot from him as an artist in the early years and had developed as a painter, she realizes after ten years of cohabitation and two children that she can no longer stand life with this man.

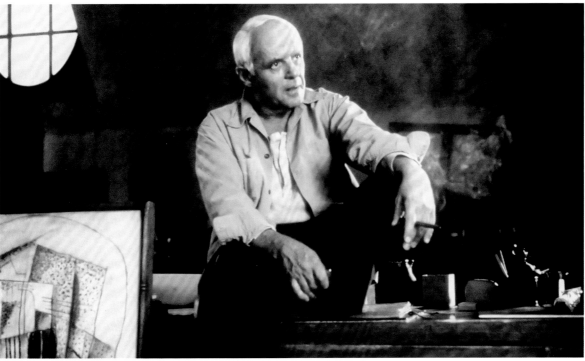

Picture list:

p. 6 top: Palais de L'Electricité, Paris World Fair, 1900.

p. 6 bottom: *The Lapin Agile* before 1914.

p. 7 right: Picasso, *Le Moulin de la Galette*, 1900, oil on canvas, 90 x 116 cm, private collection, New York.

p. 7 bottom: Eiffel Tower, Paris.

p. 8: Poster for the World Fair, Paris 1889.

p. 10 top: Jules Arnout from a drawing by Felix Benoist, *Les Halles Paris*, no. 69 of the *Paris dans Sa Splendeur series*, color lithograph, 1861.

p. 10 bottom: Claude Monet, *Gare Saint-Lazare*, 1877, oil on canvas, 75.5 x 104 cm, Musée d'Orsay, Paris.

p. 11: Georges Seurat, *Sunday Afternoon on La Grande Jatte*, 1884–1886, oil on canvas, 207.5 x 308 cm, Art Institute of Chicago.

p. 12: Camille Lefebre, *Levassor Monument*, marble relief after Jules Dalou, Porte Maillot, Paris, 1907.

p. 13: Comte Lambert's flight around the Eiffel Tower in a Wright Brothers' aircraft, contemporary postcard, 1909.

p. 14: Contemporary postcard of the second-level platform of the Eiffel Tower.

p. 15: Street scene, Boulevard des Italiens/Boulevard Montmartre, color print from painting, c. 1900.

p. 16: Georges Seurat, *Eiffel Tower*, oil on canvas, 45.46 x 70.74 cm, Fine Arts Museum, San Francisco.

p. 17: Paul Cézanne, *Mont Sainte-Victoire*, 1904–1906, oil on canvas, 60 x 72 cm, Kunstmuseum Basel, Basel.

p. 20 top: *Els Quatre Gats*, Barcelona, photo c. 1899.

p. 20 bottom: Picasso, *Daniel-Henry Kahnweiler*, 1901, oil on canvas, 100.6 x 72.8 cm, Art Institute of Chicago.

p. 21 left: Picasso, *Ambroise Vollard*, 1910, oil on canvas, 93 x 66 cm, Pushkin Museum, Moscow.

p. 21 right: Max Jacob, photo 1915.

p. 22: Picasso, *Self-Portrait*, 1901, oil on canvas, 81 x 60 cm, Musée Picasso, Paris.

p. 24 left: Picasso, *Self-Portrait with Palette*, 1906, oil on canvas, 92 x 73 cm, Philadelphia Art Museum.

p. 24 right: Picasso, *Seated Old Man*, 1970/71, oil on canvas, 144.5 x 114 cm, Musée Picasso, Paris.

p. 25 left: Picasso at work during the shooting of Henri-Georges Clouzot's documentary film.

p. 25 right: Picasso and Françoise Gilot on the beach, with Picasso's nephew Javier Vilato in the background, 1948.

p. 26: Picasso in a striped top, with bread rolls for fingers.

p. 27 top: Ambroise Vollard.

p. 27 bottom: Daniel-Henry Kahnweiler.

pp. 28–29: Picasso, *The Three Musicians*, 1921, 188 x 203 cm, oil on canvas, Museum of Modern Art, New York.

p. 30: Picasso, *Dance*, 1925, oil on canvas, 215 x 140 cm, Tate Gallery, London.

p. 31: Picasso, *Studio with Plaster Head*, 1925, oil on canvas, 98.1 x 131.2 cm, Museum of Modern Art, New York.

p. 34 top left: Picasso, *Violin and Music*, 1912, paper stuck on card, 78 x 65 cm, Musée Picasso, Paris.

p. 34 top right: Picasso, *Violin*, 1913/14, cardboard box, pieces of paper, gouache, charcoal, crayon on card, 51.5 x 30 x 4 cm, Musée Picasso, Paris.

p. 34 bottom: Grebo mask, wood, white paint, 64 x 25.5 x 16 cm, Ivory Coast.

p. 35: Paul Cézanne, *Still-Life with Curtain*, 1898/99, oil on canvas, 54.7 x 74 cm, Hermitage, St. Petersburg.

p. 36: Picasso, *Life*, 1903, oil on canvas, 196.5 x 128.5 cm, Cleveland Museum of Art, Cleveland, Ohio.

p. 38 left: Picasso, *Pierreuse*, 1901, oil on canvas, 69.5 x 57 cm, Museu Picasso, Barcelona.

p. 38 right: Picasso, *Portrait of Pedro Mañach*, 1901, oil on canvas, 100.5 x 67.5 cm, National Gallery of Art, Washington.

p. 39 left: Picasso, *The Absinthe Drinker*, 1901, oil on canvas, 73 x 54 cm, Hermitage, St. Petersburg.

p. 39 right: Picasso, *The Old Guitarist*, 1903, oil on wood, 121.3 x 82.5 cm, Art Institute of Chicago.

p. 40: Picasso, *Poor People on the Seashore*, 1903, oil on wood, 105.4 x 69 cm, National Gallery of Art, Washington.

p. 41: Picasso, *The Acrobats (La Famille de saltimbanques)*, 1905, oil on canvas, 212.8 x 229.6 cm, National Gallery of Art, Washington.

p. 42: Picasso, *The Two Brothers*, 1906, gouache on card, 80 x 59 cm, Musée Picasso, Paris.

p. 43 top: Picasso, *Portrait of Gertrude Stein*, 1905/06, oil on canvas, 99.6 x 81.3 cm, Metropolitan Museum of Art, New York.

p. 43 bottom: Picasso, *Self-Portrait*, 1907, oil on canvas, 50 x 46 cm, Národní Galerie v Praze, Prague.

p. 44: Picasso, *Les Demoiselles d'Avignon*, oil on canvas, 244 x 234 cm, 1906/07, Museum of Modern Art, New York.

p. 45: Picasso, *Fruit Bowl and Bread on a Table*, 1908/09, oil on canvas, 164 x 132.5 cm, Kunstmuseum Basel, Basel.

p. 46: Picasso, *Factory in Horta de Ebro*, 1909, oil on canvas, 50.7 x 60.2 cm, Hermitage, St Petersburg.

p. 47: Picasso, *Still-Life with Wickerwork*, 1912, oil on oilcloth on canvas frame with cord, 29 x 37 cm, Musée Picasso, Paris.

p. 48: Picasso, *Seated Woman in a Blouse in an Armchair*, oil on canvas, 150 x 99.5 cm, private collection, New York.

p. 49: Picasso, *Violin*, 1915, sheet metal and wire, 100 x 63.7 x 18 cm, Musée Picasso, Paris.

p. 50 left: Picasso, *Women Running on the Shore*, 1922, oil on canvas, gouache on plywood, 32.5 x 42.1 cm, Musée Picasso, Paris.

p. 101: Picasso, *Jacqueline Roque Sitting Clasping Her Knees*, 1954, oil on canvas, 116 x 88.5 cm, Musée Picasso, Paris.

p. 102/103: Picasso, *Woman Playing with Dog*, 1953, oil on canvas, City of Lucerne Picasso Collection.

p. 104: Picasso, *Woman with Pushchair*, 1950, bronze, 203 x 145 x 66 cm, Musée Picasso, Paris.

p. 105: Picasso, *Female Nude in Rocking Chair*, 1956, oil on canvas, Art Gallery of New South Wales, Sydney.

p. 106: Picasso and Jacqueline dancing, La Californie, c. 1957.

p. 107: Picasso, *The Family*, 1970, oil on canvas, 162 x 130 cm, Musée Picasso, Paris.

p. 108: Picasso, *Jacqueline Seated with Her Cat*, 1964, oil on canvas, 195 x 130 cm, heirs of Jacqueline Picasso.

p. 109: Picasso, *Large Profile*, 1963, oil on canvas, 130 x 97 cm, Kunstsammlung Nordrhein-Westfalen, Düsseldorf. Photo: Walter Klein.

pp. 110–111: Picasso, *Large Female Nude*, 1964, oil on canvas, 140 x 195 cm, Kunsthaus Zürich.

p. 112: Picasso, *Standing Female Nude and Seated Man with Pipe*, 1968, oil on canvas, 162 x 130 cm, Galerie Rosengart, Lucerne.

p. 113: Picasso, *Musketeer and Cupid*, 1969, oil on canvas, 194.5 x 130 cm, Museum Ludwig, Cologne.

p. 116: Picasso, *Couple*, 1970, oil on plywood, 163.5 x 131.5 cm, Musée Picasso, Paris.

p. 117 top: Room with *Guernica*, Museo del Prado, Madrid.

p. 117 bottom: Musée Picasso, Paris.

p. 118 top: *Surviving Picasso*, Anthony Hopkins, film still.

p. 118 bottom: *Surviving Picasso*, Anthony Hopkins and Natascha McElhone, film still.

p. 120: Stefan Szczesny, *Seated Nude*, 1982, acrylic on canvas, 120 x 150 cm.

p. 121: Robert Kushner, *Bloomingdale's*, 1979/80, acrylic on cotton with metal brocade, 248.9 x 325.1 cm, private collection, Washington.

p. 123 top: *Surviving Picasso*, Anthony Hopkins, film still.

p. 123 bottom: *Surviving Picasso*, Anthony Hopkins and Natascha McElhone, film still.

If you want to know more:

PICASSO FOR BEGINNERS:

Martin Bentham, *Picasso: A Beginner's Guide*, London / Hodder & Stoughton, 2002.

Andrew Brighton, *Picasso for Beginners*, London / Icon, 1995.

BIOGRAPHIES:

Arianna Stassinopoulos Huffington, *Picasso: Creator and Destroyer*, New York / Simon and Schuster, 1988.

Norman Mailer, *Portrait of Picasso as a Young Man: An Interpretative Biography*, New York / Atlantic Monthly Press, 1995.

Patrick O'Brian, *Pablo Ruiz Picasso: A Biography*, New York / Putnam, 1976.

John Richardson, Vol 1 *A Life of Picasso: 1881–1906*, London / Pimlico, 1992; Vol. 2 *A Life of Picasso: 1907–17: Painter of Modern Life*, London / Jonathan Cape, 1996; Vol. 3 *A Life of Picasso: Triumphant Years, 1917–1932*, London / Jonathan Cape, 2007.

MEMOIRS:

Brassaï, *Conversations with Picasso*, Chicago / University of Chicago Press, 1999.

Hélène Parmelin, *Picasso Plain: An Intimate Portrait*, New York / St Martin's Press, 1963.

Jaime Sabartés, *Picasso, an Intimate Portrait*, New York / Prentice-Hall, 1948.

Gertrude Stein, *Picasso, New York* / Dover Publications, 1984 (first published 1938).

See also Fernande Olivier and Françoise Gilot under Picasso and women.

PICASSO IN HIS OWN WORDS:

Pablo Picasso, *Picasso: In His Words*, edited by Hiro Clark, San Francisco / CollinsPublishers, 1993.

PICASSO AND WOMEN:

Mary Ann Caws, *Picasso's Weeping Woman: The Life and Art of Dora Maar*, Boston / Little, Brown, 2000.

David Douglas Duncan, *Picasso and Jacqueline*, New York / W.W. Norton, 1988.

Judi Freeman, *Picasso and the Weeping Women: The Years of Marie-Thérèse Walter & Dora Maar*, Los Angeles / Los Angeles County Museum of Art, and New York / Rizzoli, 1994.

Françoise Gilot, *Life with Picasso*, New York / McGraw-Hill, 1964.

Fernande Olivier, *Loving Picasso: The Private Journal of Fernande Olivier*, foreword and notes by Marilyn McCully, epilogue by John Richardson, New York / Harry N. Abrams, 2001 (first published as Picasso et ses amis, 1933).

PICASSO AND CHILDREN:
▪ Werner Spies, *Picasso's World of Children*, Munich and New York / Prestel, 1994.

PICASSO AND SCULPTURE:
▪ Daniel-Henry Kahnweiler, *The Sculptures of Picasso*, photographs by Brassaï, foreword by Diana Widmaier Picasso, New York / Assouline, 2005.
▪ Werner Spies, *Sculpture by Picasso, with a Catalogue of the Works*, New York / H. N. Abrams, 1971.

PICASSO AND CERAMICS:
▪ Georges Ramié, *Picasso's Ceramics*, Secaucus, N.J. / Chartwell Books, 1979.

PICASSO AND TRIBAL ART:
▪ Peter Stepan, *Picasso's Collection of African & Oceanic Art: Masters of Metamorphosis*, Munich and New York / Prestel, 2006.

CRITICAL STUDIES:
▪ John Berger, *The Success and Failure of Picasso*, New York / Pantheon Books, 1980 (first published 1965).
▪ Mary Mathews Gedo, *Picasso: Art as Autobiography*, Chicago / University of Chicago Press, 1980.

TWO KEY WORKS:
▪ *Les Demoiselles d'Avignon*
Wayne Andersen, *Picasso's Brothel: Les Demoiselles d'Avignon*, New York / Other Press, 2002.
▪ Brigitte Leal, *Les demoiselles d'Avignon: A Sketchbook*, London / Thames and Hudson, 1988. (French edition published on the occasion of the exhibition *Les Demoiselles d'Avignon* held at the Musée Picasso 26 Jan.–18 Apr., 1988)
▪ William Rubin, Héléne Seckel, Judith Cousins, *Les Demoiselles d'Avignon*, New York / The Museum of Modern Art, distributed by Harry N. Abrams, Inc., 1994.

GUERNICA
▪ Anthony Blunt, *Picasso's 'Guernica,'* London and New York / Oxford University Press, 1969.
▪ Ian Patterson, *Guernica and Total War*, Cambridge, MA. / Harvard University Press, 2007.

PICASSO ON THE WEB:
▪ The official site: http://www.picasso.fr/anglais/
▪ Also particularly useful is the Picasso Project: http://picasso.tamu.edu/picasso/

Imprint

The pictures in this book were graciously made available by the museums and
collections mentioned, or have been taken from the Publisher's archive with exception of:
Akg, Berlin: pp. 6, 9, 15, 118, 119, 123
Ullstein Bild: pp. 12, 83, 122
Look: pp. 7, 117 above
Artothek, Weilheim: pp. 11, 16, 55/56, 59
Archivio Scala: pp. 28/29, 31, 43 right, 44, 70, 77
Bridgeman: pp. 21 right, 23, 36
© Montmartre des arts, Paris : p. 7 left
© Archives Picasso : p. 25 above
© Rapho/Robert Doisneau : pp. 26, 99 left
© Focus/Robert Capa : pp. 25 below, 99 right
© Estate Brassaï – R.M.N: p. 64 above
© David Douglas Duncan: p. 106
Karl Heinz Bast: p. 27 below

Library of Congress Control Number is available
British Library Cataloguing-in-Publication Data: a catalogue record for this book is
available from the British Library. The Deutsche Bibliothek holds a record of this
publication in the Deutsche Nationalbibliografie; detailed bibliographical data can
be found under: http://dnb.ddb.de

Prestel Verlag Prestel Publishing Ltd. Prestel Publishing
Neumarkter Straße 28 4 Bloomsbury Place 900 Broadway. Suite 603
81673 Munich London WC1A 2QA New York, N.Y. 10003
Tel. +49 (0) 89 4136-0 Tel. +44 (0) 20 7323-5004 Tel. +1 (212) 995-2720
Fax +49 (0) 89 4136-2335 Fax +44 (0) 20 7636-8004 Fax +1 (212) 995-2733
www.prestel.de www.prestel.com www.prestel.com

Translated from the German by Paul Aston
Editorial direction by Claudia Stäuble
Copy-edited by Chris Murray
Series editorial and design concept by Sybille Engels, engels zahm + partner
Cover and layout by Benjamin Wolbergs
Production by René Fink, Franziska Gassner
Lithography by kaltnermedia, Bobingen
Printed and bound by C&C, China

ISBN 978-3-7913-4816-2